D1632579

THE INTERPRETATION MATTERS HANDBOOK

artspeak revisited

THE INTERPRETATION MATTERS HANDBOOK

artspeak revisited

Dany Louise

Supported by
ARTS COUNCIL ENGLAND

black dog
publishing
london uk

Contents

I do always read the labels. I've seen quite a lot of pictures, so if it's a picture and it looks like something I'm going to understand without help, I'll look first and see what era I think it's from and what I think it's about. Then I read the label to see if I was right. But if it's something that looks hard I might read the label first to give me some clues. I've found the labels here average really. I'm not sure about the Bruce Nauman, whether that was very well labelled."

Lindsey Walker from Buxton, Derbyshire
at the Preston Harris Museum & Art Gallery

"When I enter a gallery, I tend to do an initial whip about, I like to get a feel for the work as a whole, a unit. After spending some time with the piece I then make a choice to read or not to read the interpretation cards. I read the cards if I feel lost, or don't understand the context or even the thinking behind the work. If this is the case then usually the cards are important. However quite often I know roughly what I'm looking at and want to explore it further myself."

Clare Donegan from Hebden Bridge, Yorkshire
at Manchester Art Gallery

Why Does Interpretation Matter?

How often have you walked into a gallery—any gallery—read the written panels next to the artworks, and felt none the wiser? Have you felt that they haven't told you what you want to know, left you with more questions than answers, or that you just haven't understood? How frequently do you read the seemingly compulsory phrases: "questions the notion of..." or "challenges the viewers' ideas about..." without the least idea of what notions are being questioned, or why, and what supposedly wrong ideas you have that are being challenged?

Written interpretation in our galleries could be so much better. Too often it seems to obfuscate (sorry, I mean confuse) rather than elucidate (sorry, I mean explain). They can lack clarity and a satisfying narrative that anticipates what questions the visitor might have, as well as a reader-friendly tone. Sometimes they seem to be written by specialists who are trying to summarise an essay's worth of ideas into five or six sentences.

Panels can be too small, but the board sizes are rarely made larger, or increased in number. Instead complex ideas are collapsed into overly long but paradoxically too few sentences. Or the concepts are over-simplified to the point of meaninglessness. As a result, they can say little of use, and at worst, they can actively work to alienate the reader.

There are serious professional debates about interpretation. Many curators and artists think that viewers shouldn't be told what to think, and that as little as possible should be inserted between the art and the audience's experience of it. The opposing argument is that visitors, even those familiar with art, appreciate a few contextual pointers. This is where I stand. Exhibitions show such a wide range of art practices, concepts, mediums and messages that no-one can know about it all. Personally I only have so much headspace, and the more interpretative help the better in my opinion. But whichever view you take, if there are going to be wall panels and labels, wouldn't it be great if they were all brilliantly written?

That's what this book is all about. Dip in and out or read it cover to cover. I hope you find it useful, informative and entertaining. Enjoy!

A version of this text first appeared on axisweb.

KAREL HODD'S *VOLUME WITH THREE VOIDS* IN THE TURBINE HALL AT TATE BRITAIN

Art Bisected Quarterly, Volume 18, 2nd edition

This iconic work, *Volume with Three Voids*, was created for the Stratford Olympic Park development buildings, and will forever be associated with the London 2012 British podiuming triumph. With that work, Hodd questioned the paradoxical uniquity of the mass produced commodity by editioning 10,000 multiples, initially sold at £25 each. It was this audacious new paradigm that brought Hodd to the attention of a critical cluster of influential arts administrators at world-respected institutions who declared established consensual tête-à-tête regarding his outrageous, and some would say, controversial, talent.

Hodd is based between Hemel Hempstead, north of London, and Burgess Hill in Sussex, England. He went to Brighton Municipal College of Vocational Training, where he trained in the technical concepts that enable physical materiality to be bound three dimensionally in place, space and shape without disintegrating into their componential fractionality. Mastering his practise below the radar for many years, Hodd has recently come to be considered a leading practitioner of the

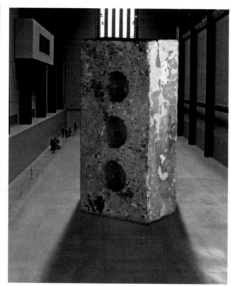

Image: Alistair Gentry

emerging post-hoc vector, with this sector esteem now being reflected in the marketplace. Following his breakthrough in 2012, a second reiteration of *Volume with Three Voids* was sold originally for £1,000 by Hodd's dealer Victor Spiro, in an intentional and humorous balanced symmetry with the edition quantification. His collateral show in the Venice

Biennale in 2013, was widely praised for its playful subversion of sculptural medians, and polemical championing of the ordinary and banal. However subsequent to Hodd's sponsored intervention in Tate Modern's Turbine Hall, (pictured above), his stock rose and the reserve for this edition of *Volume with Three Voids* at auction is frequently no less than £5,000.

Seven Problems with Art Writing

I'm a professional writer. I write about the visual arts and cultural policy for UK national broadsheets, magazines and websites, and I get paid to do so. I also undertake research projects that focus on aspects of the infrastructure for the arts and I've worked in the sector for 20 years. So it's fair to say that I do genuinely know about the arts, and I know about writing—its techniques, language, tone, what communicates well and what doesn't. From my perspective—that of critic, writer and researcher, here is why I think there are seven basic problems with art writing.

First, I suggest that writing technique matters, really matters, and that regardless of professional and academic debates, much interpretation could be improved simply by avoiding some very common mistakes and writing better. Here are three real-life examples of interpretative writing from three very different exhibitions in the UK:

Example one:
"All the works in this section have one core formal concern in common: the idea of 'time' (and space). X's creative act of dissolution combines stillness and the intimation of motion, leading us to the very edge of identifiable form and playfully subverting minimalist concerns."

Example two:
"The theme of this year's Biennial is "Agents of Change, Photography and the Politics of Space". It examines how public space is constructed, controlled and contested, and the ways in which photography is implicated in these processes.

Looking to recent efforts to re-imagine urban space through its occupation, BPB12 opens a series of dialogues: between professional photography and 'citizen imagery', grassroots activism and media spectacle; established names and recent finds; contemporary work and older photographic practices."

Example Three:
"There has been much debate about what exactly is Englishness. We struggle to define it. I wanted to make something that looked like an ethnographic artefact that was about England. At once mystical and banal, this is the skull of a decaying maritime superpower."

What do you think of these? You've probably already formed your own opinion (and one thing I've learned from this project is that everyone has an opinion on art writing). Here's my analysis.

The top quote is an example of writing for the public by an institution that is funded by Arts Council England. It is not selectively quoted, but a whole interpretation board in an exhibition. As an arts professional with a degree in fine art, I could understand what it's saying and apply it to the work. To an initiated insider, it described the work on show very well. But even so, I had to read it twice and think about what it meant. It seemed unnecessarily complicated, with a dense sentence structure that had to be broken down into its component parts in order for me to understand what it was trying to communicate. I wondered how it would come across to a visitor who hasn't done a degree in fine

art, and isn't a curator or an arts professional? I thought that they would probably find it opaque, and unlikely to genuinely help them engage with the work. For this reason, I think it could be significantly improved.

In writing terms, it suffers from two distinct problems:

1 Forcing too much information into too short a space, creating dense sentences that the reader needs to spend time unpicking and understanding.

2 Artspeak and jargon. It uses a lot of language peculiar to the discipline of art, and therefore contains words and concepts that might not be understood by readers who do not know art-world language and concepts ("artspeak" for short).

The problem is in the use of language and structure, but also with the use of concepts that are not explained. For example, "space" is a very common word when talking about art, but it has moved beyond a simple word to become an art term loaded with actual and metaphorical meaning. A casual reader might not pick up on this Similarly, a short sentence explaining Minimalism might serve as a useful reminder for those who are already familiar with it, and a helpful summary for those who have never heard of it.

The second quotation is from the Brighton Photo Biennial 2012. It's an interesting example of the difficulty in writing for two quite different audiences. It's fairly well written, intelligent and explanatory, but also dense, impersonal and semi-academic. In many ways it is appropriate to the audience that this biennial needs to appeal to in order to gain status and credibility with its peer organisations in the international arts world—that is, a perceived audience of national and ideally international curators, organisations and artists concerned with the highest levels of photography practice.

Because it needs to have this professional reach and ambition, it is important for it to have an aesthetically and intellectually robust curatorial framework and content. And it needs to communicate this very clearly. The "great art" of the content has to be at the forefront.

At the same time, the Biennial's funders—Arts Council England and the local municipal authority, amongst others—are keen that a project such as this should be accessible to local audiences, and enjoyed by them. "Great art for Everyone" is Arts Council England's guiding principle, and it is the "for everyone" that the local authority might be principally concerned about. Local audiences can be very diverse: Brighton boasts a large number of "creatives", has a population that is educated to higher than average levels, and a significant wealthy middle class. It also has some of the most deprived council wards in the country. How do you write to cover all these bases? And appeal to your national and international peers which is in the interests of your long-term professional status and sustainability?

I'd say that the Brighton Photo Biennial erred towards talking to the professionals first, and a general audience second; but that on balance it struck a justifiable balance between them.

Which is not to say that this piece of writing can't be improved. It suffers from mistakes **1** and **2** as outlined above, but also:

3 Too many sub-clauses which affects readability and therefore ease of understanding.

Could this example have been improved if each of the "dialogues" mentioned had had at least one sentence to itself, and possibly two? One to describe the oppositional themes and another to illustrate the application of it?

The third quotation was written by the artist Grayson Perry, for his 2011–2012 British Museum show The Tomb of the Unknown Craftsman. How much clearer is this? Even without visual information, it seems more direct, informative, engaging—and therefore more effective. He had many wall panels and labels with explanations and stories distributed throughout the show, and they were an absolute delight, without question enhancing the experience of the artworks he had made in response to British Museum artefacts. All of them were written in a clear, friendly, explanatory and intelligent way—without succumbing to two more common writing mistakes:

4 "Dumbing down" or patronising the audience by over-simplifying the language and omitting central concerns or concepts.

5 Unfinished narratives. Beginning a story and not finishing it. Stories hinted at but not told; gaps in timelines not explained; leaps from an artists' controversial status to sudden acceptance as establishment figure, etc.

Although the aim is not to "name and shame", Tate is big enough to take it, so here are two examples from them of number **5**. Both the recent Munch and Yoyoi Kusama exhibitions at Tate Modern had sudden jumps in narrative, leading to the dissatisfaction of being drawn into a story with a crucial part of the narrative left unfinished and untold.

In my opinion, Tate's Hirst retrospective suffered from number **4**—dumbing down. There wasn't one word of critical discussion in the leaflet handed to visitors, or in the text panels on the wall, which was an opportunity wasted and a disservice to visitors, in my opinion. Given Hirst's well known and controversial artistic status, and his own knowing exploitation of this, it should surely have been a central part of any texts written about him.

The sixth basic writing error is what my colleague Alistair Gentry calls "aphasic writing" and that I call:

6 Nonsense Writing. There are a good few examples of that in this book, and it is really common amongst more inexperienced writers. Essentially it is writing in which all the words exist and could be found in a dictionary, but they are put together in an order that simply doesn't make sense, and doesn't mean or communicate anything. Often it inappropriately juxtaposes conceptual ideas in the same sentence that simply don't belong together. Or the writer has just finished their MA and has a head stuffed full of education that they struggle to express in words, so they over complicate and confuse. Sometimes it is used deliberately in an attempt to attach status to an artwork or an exhibition that isn't warranted. However it's used though, it is always BAD writing.

To these six basic writing errors, I add a final one that really bugs me. It's what I call:

7 Dead White Male Syndrome. This appears in exhibitions of more historical works, usually by men (who are dead, white, male and privileged in life), and manifests as great and grinding detail about who their friends were, whose wife they had an affair with, and who was at an obscure dinner party on 20th August in 1932. Does the average visitor care? No, it's boring information about people we have never heard of and have no interest in.

There are probably a lot more that I could add, but this is plenty to be going on with. Of course there are many reasons why interpretation may look as it does. It has its own internal, professional, curatorial and academic practices and logic, all of which present valid cases for how it is written. Some of them are explored and discussed in this book.

But from a writer's perspective, identifying technical writing issues gives the opportunity to look and understand in a different way. If writing is technically flawed, those flaws can be addressed, improved or removed, leading to better writing.

Good interpretation matters because there is such a huge range of artistic practices and concerns being shown in galleries. No-one can hope to know and understand everything they see and experience, however well educated they are and however much art they have seen. Wall panels, labels and information sheets give viewers an instant way in to greater understanding of the work and its context, theoretically without them having to go to a great deal of effort. At its best, it enriches perception and enjoyment, without obscuring, excluding or patronising audiences. For me, good writing really is the key to good interpretation.

> *Interpretation is the revenge of the intellectual upon art.*

Susan Sontag

> *For me, interpretation that works, is something that doesn't tell me how to respond but helps me respond. Concentrating on the object just deadens it, and makes it inert. I prefer to know about how it was produced and something interesting about the producer. Suddenly the artwork becomes a living thing and gains a pulse that I can engage with.*

Johnny Gailey, Edinburgh

> *If art deserves its enormous prestige (and I think it does), then it should be able to state its purpose in relatively simple terms.*

Alain de Botton

> *It's about enriching an experience of looking, it's not about deadening it.*

Jennifer Higgie, Editor, Frieze

Tate Galleries: Leading the Way?

In May 2013, Tate Britain, located in the heart of London, opened its doors to display a new presentation of works from its extensive permanent collection. Called "A Walk through British Art", it has two distinguishing features, the first being a return to a chronological hang—the works are displayed according to the date they were made, rather than according to a theme or period. So the exhibition starts with works made in 1540 and continues through the years, finishing with works made in the twentieth century.

The second distinguishing feature is that there are far fewer explanatory labels and wall panels. This marks a radical change for Tate, since previously every work had to have a label of 120 words.

Walk Through British Art was the subject of detailed comment in the mainstream and art press. "The presentation is too often unsympathetic to the individual works" sniffed Laura Cummings of *The Observer*, but she applauded Tate Britain director Dr Penelope Curtis' decision to place labels "below the paintings, angled so you only have to dip your eyes momentarily. All the emphasis is on looking, and not reading your way round the walls." *The Financial Times* claimed that "you will be surprised, challenged, amused and—crucially—left to make your own connections". It described it as "a supremely assured presentation" that "is a vibrant intellectual reappraisal" in a "democratically flattened arrangement". *The Independent* praised the chronological imperative from a museological perspective, referring to how art history is often presented

as having a tidy linear development: "we can see for ourselves how much obfuscation has gone on in the past, how many lies or half truths the tellers of art's tale have been peddling.... it's a curatorial triumph", it declared. "The most bold and far-reaching transformation in Tate Britain's approach" cried Richard Dorment in *The Telegraph*. He goes on: "What Curtis has understood is that pictures on show in a public gallery are themselves primary data. Gallery visitors should be allowed to have their own responses to the art in front of them, not told what to think by the curator." A lone dissenting voice is Jonathan Jones of *The Guardian*: "There are no explanatory texts by the works of art", he cries in panic.

But if the national press were largely positive, the visual arts sector was slightly more reserved. On social media concerns were expressed about the paucity of wall panels and explanatory labels, and it quickly became known as the "tombstone text rehang" (referring to labels that provide only title, artist, medium and date made). The influential Maurice Davies, then at the Museums Association, was unhappy about the lack of written interpretation:

"In the building, it's easy to get lost as 'Spotlight' displays lead off many of the chronological galleries and a new commission (an installation by Simon Starling) fills the centre of the building... The inadequate interpretation means the main message often reduces to 'look, what a lot of different types of art were being produced at the same time'...."

I eventually admitted defeat. I gave up trying to understand what was going on and instead simply looked at individual works of art. My studious walk of learning became a relaxed amble of enjoyment... I'd enjoyed looking at a marvellous variety of works of art, but realised how much I had missed without easier access to the curators' knowledge and ideas."

Davies alludes to the most often stated concern: does the pared down written explanations make it a less rich and accessible experience to people without a background or education in art? Is it catering too much to a stereotypical demographic, the educated middle class visitor with leisure time and cash to spare for iPads, iPhones and helpful publications in the bookshop? What about those visitors who know very little about art, or indeed, young people, who might appreciate some short explanations of what they are looking at, easily accessible at the point of seeing? What would they get out of the experience? Would they even bother visiting, or making a return visit? As the Arts Council of England repeatedly says, great art is for everyone. Was Tate Britain doing enough to make sure it was accessible to everyone?

Clare Antrobus admits to "disliking most gallery interpretation on the grounds that it is often premised on there being a right way to interpret a work and that it tells me what to think (usually in art historical terms 'X is an important artist who was influenced by Y school of art and their use of [insert technical term] influenced a whole generation of other artists, etc etc')." She notes that the labels at the Walk Through British Art "mainly offer facts, information that you might find useful to know in looking at the work". She makes the point that labels are not confined to "tombstone" information but there are longer panels at intervals.

When I visited, I found these longer panels very helpful, and situated by the works I most wanted them by—and to which I thought visitors might genuinely need some insight into. These were largely the more conceptual or most political works, where if the context was unknown, they would be very difficult to read. I didn't miss longer labels by every work, or larger wall panels on a more regular basis. But then, I have three art degrees, review exhibitions regularly and write about art for a living. I pretty much know what I'm looking at in this kind of mainstream art historical exhibition. How would visitors react who don't not have a background in art? It may well be a shallower experience, and possibly a more intimidating one too, if they interpret the lack of labelling as a presumption that they understand, or should understand, the significance of this portrait, that history painting, this piece of sculpture, that photograph.

"They can look up the information in various ways", Dr Curtis told me (see my interview with her later on in this section). But supposing they don't have iPads and iPhones, which seems a heretical question in a climate where digital platforms are widely perceived to be the knowledge source of choice. Do we all carry around a tablet and smartphone now? And if we do, how fast is page loading? How easy is navigation, and is the screen big enough to read comfortably?

One rainy afternoon in May 2014, I asked a few visitors how they experienced the exhibition. "I noticed there wasn't as much information about the pieces as in Tate Modern", said Abbie Gordon, who works for a construction consultancy, is 31 and studied art at Foundation level (post secondary school and pre-degree in the UK). "But then I'm curious enough to go

away and look up something if I want to." She didn't have an iPad with her, but she did have an iPhone. Has she looked anything up while in the exhibition I asked? "No, because this is my time away from technology" she explains. "I would tend to buy a book in the bookshop if they had one on an artist I found interesting here." Peter and Mark are a father and son from Manchester, aged 20 and 62. Mark is a student at Goldsmiths University in London, at a campus just down the road from Tate Britain. I asked them if they thought there was enough information. "There isn't enough in the rooms", said Mark, "but with mobile phones it's not hard to find out something. I think in a way information next to a painting can be too much. You can read too much into it when it doesn't matter, the painting is what matters." They've looked up the history of Ossie Clarke from the Hockney painting *Mr and Mrs Clarke (and Percy the cat)*. "It's a favourite of mine, is that", says Mark's dad. "I originally come from a place called Oswaldtwistle in Lancashire, and he took his name from that town because he lived there for a short period." Do they find the phone screen big enough? "For me it is", says Mark "but if I was coming again I'd bring the iPad." Two French students, Anais and Adeline, aged 16 and 17, were on their first visit to London with their school. "We have seen other museums in London and sometimes there is description to explain the context of the pictures", they begin. Would they like more explanation in this exhibition? "Yes, because it helps understand the painting, to feel what the authors mean", they decide. They also did not have an iPad with them, and hadn't looked anything up on their phones because they hadn't the right application "but if I can I should" said Adeline. I approached an older gentleman, Umakanthen from Chennai in India, a retired chemical engineer. "I am a fanatic about art!" he declares,

and tells me that he has been to the National Portrait Gallery about 80 times, and has visited "around 70 per cent of the galleries in the world". He usually reads a lot before visiting a gallery, but normally prefers an audio guide while he's there, "but I do read the labels and I try to look at the pictures afterwards, otherwise for me it makes no sense." He's not keen on the audio guide at Tate Britain though, because "the audio guide here does not have any pictures".

How many visitors ask a gallery attendant for information? I wondered. According to attendant Pierre Julien, people do ask about the art, and he will consult his notes to give an answer. If it's not there he'll put a call out for the answer. He also makes a point of keeping an eye open for anyone who seems to be struggling, and will approach them if he thinks he can be helpful. That's good to know, but I do wonder how much knowledge, insight and analysis each attendant may have, and how helpful, compelling, useful, those notes they carry might be.

But it's generally a thumbs up from my short unscientific audience poll, although Tate Britain staff might like to note that mobile devices may not yet be in widespread use. Is it only those closely involved in audience and education work in the visual arts sector with reservations then? What do you think? The exhibition is absolutely worth a visit and you can leave your comments on the interpretationmatters.com website.

In the meantime, here are four pieces of writing, offering four different perspectives. In "Wordless at Tate Britain", educator Bridget McKenzie is concerned that the lack of explanatory text in the gallery might lessen experience and access. Jessica Hoare is broadly supportive in "Tate

Britain Is..." and Tate Britain director Dr Penelope Curtis explains her thinking in a comprehensive interview with me. Finally, Tate Liverpool has also been experimenting with how they present works, exploring the use of tags and word clouds. Hannah Nibblett contributes a thoughtful analysis of how this might work and for whom.

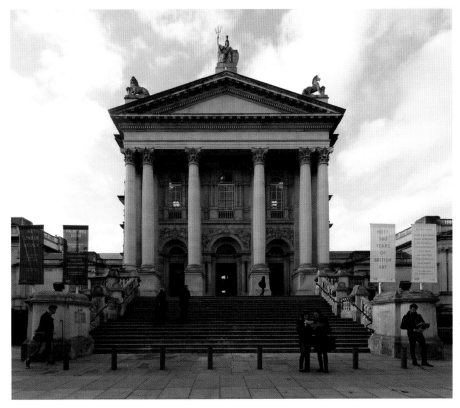

Tate Britain, London © Tate

Wordless at Tate Britain
Bridget McKenzie

My first impression was that the BP Walk through British Art meets ex-Education Minister Michael Gove's desire for schools to teach "our island story" one step in time from the age of five. I knew the hang must be chronological but still expected each room to possess and explain a linking rationale—such as a movement, links between artists, or a common centre of production. But it turned out the linking rationale for each room was simply a decade.

Some believe a strictly chronological hang provides the perfect framework for interpretation—as largely invisible yet allowing for logical historical connections. Of course, chronology is useful. But I found it a spare skeleton lacking the tools for contextual investigation. I wanted more aids to understanding—of the dynamics between places and periods, continuity and discontinuity, materials and ideas, individuals and communities.

Many artworks are ahead of, or before, or simply outside, their time—time is only one way to make sense of them. I spent most of my visit working out what was going on. I'd asked questions of five attendants about how I might find information, and it was only the fifth attendant who pointed out that the decade of each room was in small shiny lettering on the floor, and that some visitors were clutching little printed guides.

My concern was the lack of captions, and the lack of alternative provision for them. Access to the Tate's website seemed to be only via a visitor's own smartphone or tablet—and as museum educators, we can't assume that everyone has the means or inclination to use these mobile devices. And anyway, might a visitor's attention be more distracted from the art by searching for digital information, than quickly reading a label? But if an on-the-sport digital search is required, then gallery websites really must provide coherent, state of the art and mobile-friendly information.

So, how can you make informed connections between the works in each room and the decade they were made in, and then between the rooms? What to do if would like some connecting stimulus other than the works themselves?

The attendants were happy to explain the rationale behind the changes but not particularly helpful. Two attendants had the Tate Britain selection on their iPads, but weren't using them to help visitors, even when I specifically asked to see a screen. It might be slightly easier for attendants to use iPads than a physical captions folder but it wasn't serving visitors better.

On the whole, visual art does not speak

Because of my Art History training, I can articulate questions about artworks. I know the Tate's collection fairly intimately from nine years of working with it. Despite this, I still wanted prompts or reminders about

subject matter or material techniques, or different views on contested interpretations. I wondered how people would respond who don't have this background, or don't have my confidence to pester attendants with a random question about Francis Bacon's psyche or whatever? There is a printed guide costing £1, but it doesn't explain the chronological history of British art room by room. It introduces the re-hang, then promotes some "focus displays" and upcoming exhibitions. All this adds up to a serious lack of consideration for people with a range of different access needs.

On the whole, visual art does not speak, although it can stimulate thoughts and feelings, and provoke a great variety of meaning-making in different viewers. I know from my own delivery and evaluation of many museum and art projects that people need a mix or choice of different modes and layers of interpretation. These modes need to be carefully designed for the right stimuli at the right time or place. They might provoke visceral, sensory, ethereal, aesthetic or emotional responses. They might use images or sounds as well as straightforward texts.

I'm not against an approach that is open-ended and aesthetically spacious, as this new curatorial vision aims for. However, the more critical dimensions of meaning-making are missing: the communal (dialogue and other views), contextual (background in time and place), cognitive (articulating a critical response) and adaptive (how learning from this might affect my values and actions). I was also surprised at the extent of mentions of international oil company BP, given the contested nature of their sponsorship. I've never seen the brand so integrated into display titles and signage before. For me, this seemed to connect with the removal of critical and contextual information around the collection.

Interpreting art is a combination of reading *in* your own meanings, and reading *out* meanings from the work itself, or from an investigation of its context. The work of interpretation is a dance between subjective and objective. If you remove cues, it is an odd, vague experience. You could lose the motivation to *look* in an engaged way and settle for aesthetic pleasure only. Many people need some cognitive and factual elements first before they can relax into sensory and emotional experiences. They want to know the basics, or have a nagging question answered, or they simply need *clues* about how to approach a set of artworks. I had the distracting feeling that people without access to smartphones or an Art History education were being insulted.

I don't insist that information should be always on the walls, but I do believe that a publicly funded museum has a duty to provide it somehow—*freely, visibly and accessibly*—whether by loaning portable devices, providing free printed guides, or by recruiting more informed and active gallery staff. As Sanna Hirvonen, from Kiasma Museum in Finland, has said: "Letting art speak for itself means letting art speak to few. Museums should do more."

Bridget McKenzie is director of Flow UK, a cultural learning consultancy. She has been Education Officer at Tate, and Head of Learning at the British Library, and has supported many museums with digital and interpretation strategies.

Tate Britain Is...
Jessica Hoare

Writer and arts professional Jessica Hoare found the new hang full of conversation and engagement. If staffing levels and their training can be maintained, she thinks that this direct dialogic approach is an exciting development at Tate Britain. Here's her take on it.

Having written interpretation for a national museum and studied on a course which largely equated accessibility with interpretation (textual and otherwise), I approached the newly hung Tate Britain collection with an open mind. I had heard Dr Penelope Curtis discuss the changes in detail at the 2012 Association of Art Historians conference, so I had some idea about what to expect.

Labels have been reduced to "tombstone" information: artist, title, date and medium. Not all interpretation has been removed and the new hang is far from interpretation free. Key works, such as Francis Bacon's *Three Studies for Figures at the Base of a Crucifixion,* c 1944 are still accompanied by text, and AV terminals supply further interpretation.

One argument against this form of cherry-picking— effectively giving more profile to one work than another —is that it can propagate a version of art history which is pliable to a museum's agenda. There is an increasing and justified push to understand history as a process of repeated interpretation rather than the act of committing facts to paper in the name of posterity.

What does this mean at Tate Britain? Well for a start, chatter now fills the galleries. Instead of visitors engaged in solemn procession from work to work, with a swift look at a painting followed by an extended study of the text panel, I watched an elderly man attempt to recreate the stance of a horse. I overheard school pupils, stood in front of *The Mud Bath,* 1914, debate amongst themselves whether David Bomberg could have worked as a graphic designer.

The Mud Bath, 1914, David Bomberg ©Tate London 2014.

I saw other visitors discussing features of works and playful, commercial, socio-political and formalist readings abounded. When more information was needed I heard two separate parties seek out a member of staff. If staffing levels and training can be maintained and funded

in line with demand, then I think that this direct dialogic approach is an exciting one. Tate Britain has reached past factual interpretation sanctioned by professionals—it now offers a creative exchange with its visitors, one that feels both dynamic and timely.

The juxtaposition of works from different periods provokes enquiry and fosters thematic links across chronology. It also allows the climate of artistic production to surface without the need for tautological language. I found this most striking when confronted by a group of works from 1949. These works anticipate Herbert Read's critique of the British Pavilion at the 1952 Venice Biennale, in which he coined the term the "geometry of fear". Granted, my art history education provided this context, but it seemed to me that the works chosen visually resonated with this bleak period of post-atomic uncertainty.

Elsewhere contrast is used effectively to suggest context. Henry Moore's *Maquettes for Madonna and Child*, 1943, are beside *Three Studies for Figures at the Base of a Crucifixion*. This placement articulates the idea that many different forms of artistic production occur simultaneously, that there is no unified form of production in any given period.

Leaving Tate Britain, I made my way to Bowie is... at the Victoria and Albert Museum. This quote greeted me as I walked in: "All art is unstable. Its meaning is not necessarily that implied by the artist. There is no authoritative voice. There are only multiple meanings." David Bowie, 1995.

Perhaps this is one piece of interpretation Tate Britain could have used in its re-hang?

Jessica Hoare is a writer and arts professional, currently working at Watershed, a cross-artform organisation based in Bristol.

"It was good to know where everything was to start with from the map, and to know a little bit about the artists. I generally go round the outside of an exhibition and come back to the middle. One of the artists isn't written about and so I wasn't sure if she was part of the exhibition or not."

Julia Hopkins at G39 in Cardiff

In her Own Words: Dr Penelope Curtis

Having read the commentary, I asked Dr Penelope Curtis, the Director of Tate Britain, lots of nosy questions.

Here's what she said:

What is the thinking behind the new display?

When I was appointed [in 2009] it was on a ticket to provide the content and the rethinking of the interior of the gallery to coincide with the building project. The building project was very much about understanding the logic of the gallery, its history, its archaeology, and trying to make it simpler again. I wanted to find something that was very sympathetic to that. I've always been interested in letting the works do some of the navigation, and letting the architecture do navigation, giving you pointers. So rather than telling people this is Room 1, or telling people the way they should go and where the exhibition continues, the architecture should where possible show you the next step. The architecture here, at Tate Britain, with these long enfilades of galleries which give on to each other, was a gift really, to a kind of promenade approach.[1] I think a lot of people do like to walk around a museum, without pausing very often but just when they want to, just getting an overview. I wanted people to feel a natural sense of "I can see where I'm going, and I can see where I am", rather than breaking the galleries up into individual units.

[1] Enfilades are "an interconnected group of rooms arranged usually in a row with each room opening into the next".

So we have an outer perimeter which is quite loosely labelled and that in a sense tells its own story, which doesn't need a lot of explanation. The Spotlights [rooms with specific themes or artists work] have quite a lot of explanation.

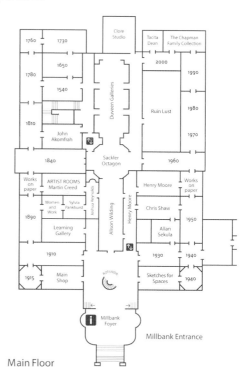

Walk Through British Art Floor Plan ©Tate London 2014.

Previously each of the galleries had a topic or theme, and each one had to be re-introduced because each was doing something different. Here I wanted to try to give a sense of coherence and flow. Because it's arranged chronologically, and you can see the dates on the threshold as you cross over, you can see where you're going. So we didn't need a panel to introduce every new room, because essentially every room was doing the *same* thing, but for a different period of years. We really built the galleries so that temporary exhibitions didn't always get in the way of the permanent collection. The key hope was that we hung the collection as one collection, not as bits of a collection broken up into historical periods. We were keen that people feel that the past flows into the present and that there are no distinctive breaks between any one period and the next.

The chronological hang was my concept although lots of people made it happen. I wanted to have something that was semi-permanent and a good introduction to the whole collection. Then I wanted to have other galleries that were changing and more provocative and more authored, so that we pleased different audiences. Normally there is a big schism between people who want to see the *same thing*, and people who want to see *different* things. People who think we've taken off the old favourites, and people who want to see us using the collection much more actively. I thought, "we can never please both those audiences at the same time, so lets divide the gallery into two zones". That's the big concept to me, not the chronological hang.

The hope was that we could be more pluralist. I strongly believe that there are different ways of learning and we always downplay visual learning. Very often you don't want to learn more until you've started to enjoy something. I'd rather the walkthrough was an invitation to enjoy, and that you didn't feel you had to read lots of stuff to understand. If people enjoy that, then there are plenty of ways they can find out more. People can if they want search an artist or a work immediately on our website, or they can buy the companion guide, or they can go to the computer terminals. But I didn't want to put that first. I wanted there to be a place in the gallery where you could *look* first and read later.

Our Learning Department has a very strong belief that the Tate is for all, and I believe that too. It's really just what you think that entails. My approach is "let's have some areas where people can really use their eyes, and learn to love the art before they have to read about it". I'm not against words, it's just the context. Jenny Batchelor, our Head of Interpretation would say, "they won't do that if they feel there are things they don't know. They'll want to know." So that's the debate, but I feel we're offering different options.

How did you make the new hang happen?
I wanted to give the Tate a chance to be more visual, and less interpreted—this is quite central to me. But it was a long and unclear process because there are so many departments here. I was really supported by our Head of Visitor Experience, who said, "we can do this, it's not impossible to change". Our Head of Displays also supported me. Our Head of Interpretation was nonplussed to say the least. She knew I was genuine and we were quite honest with each other. I wouldn't say she agreed with me. But there are quite a lot of other opportunities where we can do more interpretation than before. The Spotlights and the [temporary]

exhibitions, where necessary, have many more than our standard 120 word labels.

The signage question involved a lot of people. We worked with John Morgan who was important as a designer in trying to achieve something consistent between the big signs and the labels. The detail of where the longer labels were in the perimeter was decided by our Head of Displays and Head of Interpretation. They've asked the questions: "Where is something a bit more general needed to help locate the reader or the visitor in that room? Where would you be at a loss if you didn't know something?" I think that's going to be an ongoing debate. But we certainly haven't eradicated textual labels from the gallery—it's just that they appear now in different forms, sometimes longer, sometimes shorter, sometimes none. I did read them all and made very few corrections. I think by then we knew where we were and what we were trying to achieve.

The full evaluation hasn't happened yet because we wanted to wait until the building had properly opened and people had found their way around. Quite a lot of people were talking about it before the building was even finished, and at that point the routes were unclear anyway. At the moment, everyone is invited to make a comment, and quite a lot of people do. It's been well received by the visitors—positive comments vastly outnumber the negative comments. We've had an interim evaluation which was quite positive really, and certainly gave us the confidence to proceed in this way.

How do you understand the role of interpretation?
The role of written texts and labels is to provide key information where there is no other way to do it. There are times when it's a stand-in for a person. Sometimes you don't need text, but sometimes there is something you need to know. I read the panels and labels because they're really important and I think if they are not asking the right questions, or are written in a kind of overly simplistic language then that's not right. So in a way I set *more* store by them.

Interpretation is a word I find quite difficult, because I feel we can't *give* people interpretation. Interpretation is what you do as a looker. You think and interpret and decide, and that's what you come out with. What I like about the Spotlight [exhibition] is that it's one room, it has an argument or a point, and we can say who *did* it. It's much easier where there is a personal point of view—this is *that person's* interpretation. I think the idea of an institutional interpretation is inherently problematic. In the walkthrough—because it's a permanent collection and it's effectively unauthored because so many people were involved—it would be very hard to say "this is someone's view".

What are the problems with labelling?
I came from a background where people quite regularly told me they found labels really unhelpful. Whoever you are, however much you know, you do tend to read the label first. It's almost impossible not to. Then it just colours your vision and you don't *look* properly. It doesn't allow the picture to come *first*.

I think over the last 20 years interpretation has become a holy cow really, that you put up more labelling than maybe you always need. What I feel, personally—although this is born out by our surveys and the comment cards we get—was that this re-hang didn't need a lot of explanation because it was quite transparent.

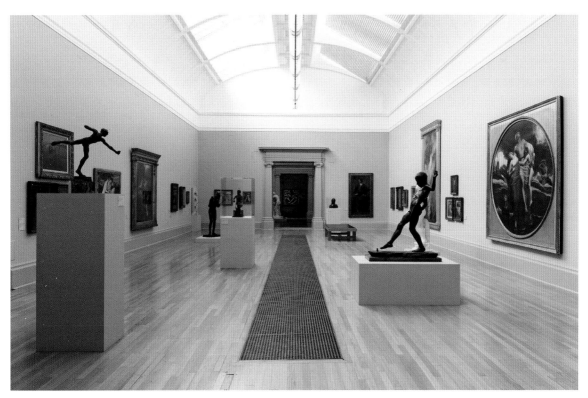

Gallery view Tate Britain ©Tate London 2014.

With the temporary exhibitions, I let the curators decide what they think is right. But there *is* a big internal debate. It becomes a kind of production line, and it can be hard for all the people who ought to take an interest in it to take interest. It's the departmentalisation of it that's the trouble. The curators do the business of putting the show on and the learning department do the business of interpretation. It's too separate. Even if a curator doesn't like a panel, they think, oh well, I'm never going to win that one, because it's in the Learning Department. What happens in a big organisation like this is that standards just become adopted as a default practice. I say to curators, "if it doesn't need a panel, don't put one up. Or if it doesn't need 400 words, then just use 100, that's fine". But even saying things like that seems to be so different.

I also think that the way that many people have been trained on curatorial courses is to *really* focus on the label. Because actually, people can't teach selecting, hanging, curating, but they can teach about writing labels. You can do more by having something low or high, or next to this or next to ten of these rather than one of those. Those things can make more difference than a label.

What is your advice to other UK public galleries?
The most important thing we can do as curators is a) the selection and b) how you hang it, the way you let things speak to each other, and then see the architecture. All those are more important and have more impact than most labels. We ought to prioritise the looking *more* in an art gallery. I feel very strongly about that.

I think there's too much labelling and it's variable in quality. Sometimes it can be very good and other times it can be formulaic. Probably at the moment, if you go into almost any gallery in Britain, there will be an introductory panel of 200 words, and then there will be long labels beside many of the works. It has just become an absolute blueprint and it becomes *unthinking*. Because it has become so standard, too many are written by too many people, with too little time, so few of them are as good as they could be. The birth of the adhesive letter or decals has been terribly bad for art galleries! They go up on the wall over and over again and it's just too easy! My advice is not to feel that it's always necessary. Ask a lot of your texts, and if they are helping anyone understand? Be more varied, and be more pluralistic. I feel that the author's voice is important and whenever there is an author behind a project, you do want to hear that author.

It has become very hard to say that you don't want so much. I think galleries should argue for it [with Arts Council England] because interpretation doesn't need to be textual. And the Arts Council should give curators and galleries licence to not have written interpretation if it doesn't help.

Penelope Curtis has a BA in history, and MA and PhD in art history. She worked in Tate Liverpool from 1988 to 1994. She then worked in Leeds City Art Gallery for six years, before transferring to the Henry Moore Foundation where she set up the Henry Moore Institute, which she directed for ten years. As Director of Tate Britain, she is responsible for the shape the gallery collection and exhibition programme takes, and for representing the gallery.

Choosing my Words Carefully
Hannah Nibblett

Tate Liverpool has been piloting an approach using "word clouds" and "tags" as a means of interpretation. Tate Liverpool's Mike Pinnington explains: "We are further refining the Constellations approach by encouraging our audience to interact with and make their own connections between works, resulting in original word clouds. We experimented with this first with the Marina Abramović Constellation. This new audience-generated interpretation went up in the gallery, replacing the original in-house Abramović word cloud. Our ultimate goal is to make the word clouds genuinely interactive, demonstrating a real commitment to inclusive interpretation."

Collections access specialist Hannah Niblett discusses this approach to words at Tate Liverpool. Do "word clouds" give access to more people, rather than deeper access to a few?

I'm very interested in the relationship between works of art and the words we use to describe them. The discourse around art has become pretty self-referential and uncritical. If you don't have the internal dictionary to translate terms such as "readymade", "abjection" or "gestalt" you'll struggle to find meaning in works of art, and perhaps feel excluded from the whole topic. It's no wonder people say modern art galleries "just aren't for me".

Tate Liverpool proposes a new solution to this problem in the collection displays that opened in 2013: DLA Piper Series: Constellations. The premise is an idea of art history as non-linear, grouping works of art from across

the twentieth century in thematic "constellations". In addition to some extensive but fairly standard text panels and labels, they've introduced something we recognise from the digital world: tags and word clouds.

Assistant Curator Eleanor Clayton explained the thinking behind the word clouds to me:

"It is important that people feel that they can choose how they engage with the art—some people may not want to read a lot of text and instead prefer to focus on their interaction with the artwork. The word clouds emphasise these options as you can simply read the word clouds and associated words next to each work to give suggestions of connections, which the viewer can then elaborate on or extrapolate from their own perspective and experience."

Eleanor's emphasis on choice is key to this strategy and draws inspiration from how content works on the web. In the virtual world, content is highly accessible and user-friendly. We aren't expected to read the entire contents of a website. Tags allow us to search out content that is of interest, and to navigate in a dynamic and personalised way.

The word clouds in Constellations float above the more detailed narrative labels. The visual nature of the word cloud gives an immediate feel for the themes— the ideas that are prominent, and those that are more

peripheral. These carefully chosen words function as a 'way-in' to the individual artworks, from which you can either "elaborate and extrapolate" your own meaning, or develop understanding by reading the interpretive text. This approach really worked for me. Navigating around the displays, I found myself cross-referencing different pieces, going off on intellectual tangents and having loads of those sparky little moments when you make complex ideas fit together.

I was enthusiastic, but on my second visit I became uncomfortable. As someone who is already confident in 'joining the dots' between works of twentieth-century art, was I getting something out of the experience that some others around me were not?

To some extent the word clouds approach still relies on the viewer having that internal dictionary of art historical terms. Does reorganising words such as "abstraction", "performativity", "installation" and "flux" in this way make it more accessible? As in, give access to *more* people, rather than deeper access to a few? This second visit was with a friend who doesn't have a visual arts background. She relied more on the labels and wall panels and found that, although the word clouds seemed to be offering ways in, some of the narrative labels put up new barriers. She asked whether I understood this label for Julius Koller's Continuation/Stoop (*Universal-Cultural Futurological Operation*):

"Koller has defined his work as a sort of 'anti-academicism'. The photographs show a door constructed from two glass panels, the lower of which has been removed. The absurdity of the artist's pose as he stoops to step through the lower half of the door recalls Koller's early

enthusiasm for Dada. The second part of the title is one of Koller's many variations on the initials UFO. Koller's work aims at a constant questioning of the world and the cultural context, opening up possibilities for utopias in unexpected places."

I didn't. There are a lot of unexplained ideas here that aren't clarified by the two tags "Infinite permutations" and "Entropy". We went back through this constellation, which centred on Robert Morris' *Untitled 1965/71*, and managed to cobble together something about the interface with the body as providing infinite permutations and a sort of entropy as the body wears down the environment and vice-versa. But even with an above average amount of cultural literacy between us, this was hard work and not especially satisfying.

On the flip side, a really good example of demystifying terms was in the same constellation:

"Morris insisted that... *forms should 'create strong gestalt sensations'—'gestalts' being patterns or configurations in which the whole has a significance greater than, and different from, the sum of its parts taken individually. Untitled 1965/71 is a perfect example of gestalt: its four elements together produce complex interactions with the environment in which they are placed and the spectator who walks between them, whilst retaining their simple identity."*

Brilliant! A new definition for my internal dictionary.

But I am disappointed that my idea of Constellations offering an art historical primer is only partially accurate. If you aren't already familiar with the terminology you can't rely on the traditional labels and wall panels to help,

DLA Piper Series: Constellations © Tate Liverpool

and it takes work to create your own definitions from the word clouds.

But there is also a lot to be applauded. Accompanying family activities have included workshops to make your own 'constellation', helping younger visitors explore the idea of non-linear connections. Blogs and online reviews about the display show that this reorganisation of art history is engaging and empowering in and of itself. But with the Keywords: Art, Culture and Society in 1980s Britain exhibition at Tate Liverpool in 2014, it seems there is sincere enthusiasm for further exploration of this idea of tags as access points. It will be interesting to see how it develops.

Hannah is an engagement professional based in Manchester, working across the arts and heritage sector. She currently works with the Whitworth Art Gallery, Manchester Central Library and the Ahmed Iqbal Ullah Race Archive at the University of Manchester. She is also studying for an MA in Museum Studies.

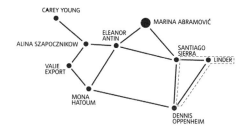

MARINA ABRAMOVIĆ
Rhythm 0 1974

Rhythm 0 was the last in a series of five 'Rhythm' works performed by Marina Abramović between 1973 and 1974. These works used performance to test her body's endurance and psychic limits, making it both object and subject of the artistic action while exploring its capacity to embody the mental processes of conceptual art.

Rhythm 0 was a six-hour performance at Galleria Studio Morra in Naples during which Abramović allowed herself to be manipulated by the public in any way they chose, using a range of objects laid on a table, such as grooming tools, food and weapons. The artist submits her body to a 'dialogue of energy' with the audience, who are implicated in the collective generation of meaning. Drawing on traditions of self-flagellation, catharsis and mythology, Abramović engages with unfamiliar ethical territory through being

manipulated by the audience to create a powerful essay in submission.

As the documentation shows, the performance evolved into one of constructed trauma, ending with the artist holding a loaded gun against her own head, with tears in her eyes, her blouse pulled open to expose her breasts, and bleeding from a head wound. Abramović commented: 'That was the heaviest piece I ever did because I wasn't in control. The audience was in control.'

The surrounding works extend the significance of *Rhythm 0* by tracing a concern with performative endurance, abjection and theatricality, in which the body is used to reveal hidden meanings and trauma is presented as a form of sculptural language.

Abramović © Tate Liverpool

So there you have it. The final word on the subject? I suspect not, but it does give a real indication of how complex it is to make changes to practices that have been entrenched for years, if not decades. In terms of organisational culture, sometimes any change in exhibition practice, of whatever size and scope, can seem radical to the people involved. And an organisation like Tate does it very publicly—the stakes are pretty high.

 Museum of Unreason

A mediocre museum tells.
A good museum explains.
A superior museum demonstrates.
A great museum inspires others to see for themselves.

March 2014

 Adrian Searle

Someone somewhere is always talking about challenging our expectations, our assumptions & preconceptions. Whoever you are, just stop it.

The Guardian visual art critic · May 2014

 Martin Herbert

Someone please, please, please invent a programme that takes all the curator speak out of exhibition reviews #editinghell

Associate Editor of Art Review · April 2014

 Catherine Herbert

Dear gallery education teams, why use so many exclamation marks? To make it more fun?
Best wishes, grown up gallery visitors.

Whitstable Biennale · November 2013

The Artist Experience:
Emily Speed

What is the artist's experience of how their work is presented? Artist Emily Speed gives an insight into how text has been produced for two of her exhibitions.

DL: What are the major themes of your work?

ES: My major themes are basically bodies and buildings, and the relationship between the two. How we're shaped by places that we live in or occupy, and also the psychological space we occupy in our own bodies. There's a point at which you realise that your work always comes back to the same thing, even if you don't know that at the time.

I've always been interested in architecture, and my grandfather was an architect, which was probably a very formative relationship. Living and working in Liverpool has also had an influence, because it's a city so much in flux architecturally. There are so many empty buildings, but at the same time, there have been so many new buildings built in recent years. The tension between the two almost holds it in stasis—is the city being demolished or is it being built?

DL: What material forms does your work take?

ES: I'm more defined by the ideas, so they tend to take whatever form they need to. I often use throwaway materials like cardboard and found pieces of wood, but

I work between sculpture, performance, drawing and text. Using other people's bodies as materials, especially acrobats' bodies, is something I have been exploring recently.

DL: Some artists think that their work should speak for itself, and that the viewer should have an unmediated experience of it. They prefer not to have any panels or texts next to the work. Where do you stand on this?

ES: I don't think that. I think there is room for both. It's really desirable for someone to just have a reaction to your work, and simply be affected or moved by it. But as an artist I put in a lot of thought, research and development time, so there are a lot of details I want people to know about as well. I think text can be really vital to give people that extra depth or enhanced experience of the work.

DL: You exhibited at both Castlefield Gallery in Manchester, and at Leeds Art Gallery in 2013. What was the process of creating written interpretation for your work in these venues?

ES: It wasn't the same in each place, although both curators are very experienced at working with artists and were flexible and waited till the work was ready, which wasn't till the very end! At Castlefield, we had lots of verbal conversation, along

with me sending key words and phrases to Clarissa [curator at Castlefield Gallery] as I went along. It was a kind of drip-feed as I updated her about making the work. At Castlefield they also commissioned an essay about mine and Haley Newman's work from Tracey Warr, so that was a different perspective as well, and also a valuable legacy from the exhibition.

At Leeds Art Gallery, the work was really being made up until the show opened. Sarah Brown [curator at Leeds Art Gallery] and I wrote it during the install week together. It began with press release text, which I had gone off, as it didn't really represent the work anymore, so I re-wrote it. She added all the nuts and bolts, and it went through at least two more people as well. I think people did add things, like clarifying that Giotto was working during the Renaissance for example, all the things I'd taken for granted because I was so close to it all.

DL: Did you write about your work yourself? Or does the curator or director write about your work?

ES: At Castlefield Gallery, Clarissa wrote about my work, but I had a chance to read through and edit it before it went out, although I didn't really change too much. But at Leeds Art Gallery, it was much more of a conversation. Because of the way the work was made, it really came together on site, and it was necessary to have that input in that week.

In some circumstances, if I've been very busy up till the opening, I have just okayed things, and afterwards thought, "I should have given that more attention". But with every show I've done, there's always been a lot of conversation. I think I've been lucky that curators I've worked with have been very careful about that. It's usually only when it gets to the press that mistakes get made.

DL: Who has the final word on the interpretation texts?

ES: I think the artist can have, although you might have to be quite outspoken, but I think the opportunity is always there to negotiate that. The situation is perhaps only different when it's a big group show. The context is different, and the curator's attention is spread between so many artists. I think they often just take text from your website in that situation!

DL: What advice would you give to other artists?

ES: It can be quite an intimidating situation, especially if you are early in your career. But you can't always presume that the curator will do the best job in representing your work in the way you'd like. I think the best job is done between the artist and the curator. So basically, pipe up if you're not happy! It's your work so you have to be pro-active about how it's spoken about.

DL: As a gallery visitor as well as an artist, do you have any general comments or opinions about text panels in exhibitions?

ES: I like them to be simple, genuine and clear. I really don't like it when a panel tells me what I should be feeling or thinking about in relation to a piece of work. You often get phrases like, "this reminds us of..." and I find that an arrogant presumption. Really, I want to know what the artist was thinking about and looking at in their research when they were making the work, and that is all.

Emily Speed is an artist based in Liverpool. She has undertaken many residencies and exhibited in the UK and internationally. In 2013, she was nominated for the Northern Art Prize and exhibited new work at both the Castlefield Gallery in Manchester and at Leeds Art Gallery. Emily is the 2014/2015 Derek Hill Foundation Scholar at the British School at Rome.

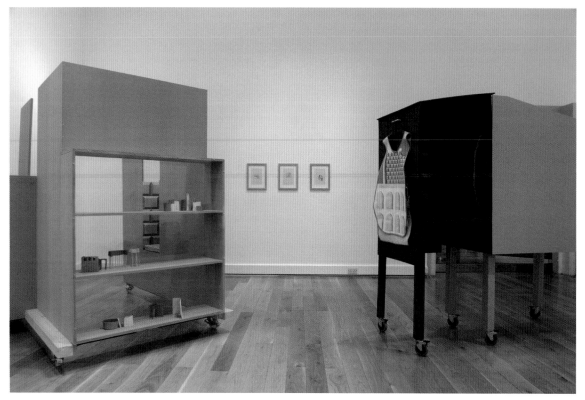

Carapaces, 2013, Wood, paint, fabric, clay, performers, Leeds Art Gallery, Photo by Simon Warner

Facades/Flats, 2012. Wood, paint, olive oil, paper, graphite powder, ceramic tiles, Photo by Michele Alberto Sereni

The Artist Experience: David Blandy

David Blandy's work seems immediately familiar and appealing because it references 1980s and 1990s popular culture, with arcade gaming and Japanese Manga comics featuring prominently. There's a particular kind of childhood and teenage experience being referenced, mostly boyish and male. But his use of these references is cover for a deeper concern about how obsessions can mask a need to find meaning in life, and the challenge of choosing who, and how, to be in the world.

Because his work is layered, and in a way, disguised, it can be hard for galleries to write about. It's often immediately accessible, because of his use of recognisable forms, but how to suggest that the arcade game is not just an arcade game? That lip-syncing to the Wu Tang Clan's "Bring Da Ruckus" while on a London tube escalator is not just David pretending to be a pop star? Or is it the case that, as he says, "if you're looking at something in a gallery then the whole question of whether it's art or not becomes redundant".

Several pieces of David's work are opaque, especially when he takes on alternative personae, as he did for the Barefoot Lone Pilgrim, a fictional Shaolin monk living as a hermit in Surrey (amongst other adventures). It became even more complicated with his work for the Liverpool Biennial in 2008, when David imagined the Barefoot Lone Pilgrim on a quest to find American soul singer Mingering Mike, another artist's fictional creation....

His latest project is *Biters*, with artist Larry Achiampong. They've turned themselves into a hip-hop crew performing live with "bitten" (sampled, borrowed, stolen) fragments of hip hop texts and beats. Audiences at Spike Island in Bristol, Modern Art Oxford, and the 198 gallery in Brixton, London, had the opportunity to experience it, before they installed themselves at INIVA in London for a month long residency.

David has exhibited all over the world and in the UK, so what are his view on labels and wall panels? "For me the words are there to create context, they're not necessarily to explain the work", he says. "When I had my show at CREATE we chose not to have any labels at all. There was a title, an information sheet, which you could pick up if you wanted to, or not", he explains. "But we knew we had a very specific art audience so I had the freedom to do that." Does he think it's a different situation in publicly funded galleries that are trying to attract a broader audience? "I usually prefer one panel for the whole show, or sections of the show, with decisions made specifically for each exhibition and work. Ideally, I like texts to be as discrete as possible so it's not overwhelming." He cites the common complaint about labels: "There's always that problem in where people spend longer looking at the panels than the work."

We talk about how galleries have produced writing about his work. It varies, but he finds there is a consistent

issue because of the nature and forms his work takes. "There is a lot of justification of why my work, or aspects of my work, is art, particularly in a public institution where, for example, I am exhibiting a computer game. The arcade games are artworks that take the form of an arcade machine. I can see how someone who is not familiar with my work or contemporary art might not understand why it might be art. So that sort of explanation becomes necessary in that situation. It partly goes with the youth of the medium."

Is this the same in commercial galleries, I wonder, who tend not to use labels or wall panels at all? To an extent it is, "even if there are only labels, certain information is needed for potential sales", says David. So there will always be a title, "which the artist has complete control over", a date, length if it's a video work, and materials used. "I always credit collaborators and funders as well", he says. "But commercial galleries do run on a different remit. Artists are probably happier with that situation because audiences are forced to make up their own mind about what they're looking at. They don't have to justify their position."

I ask him where problems come in. "I think often wall texts fall into art terminology and it can become slightly obtuse. It tries to say too much rather than say nothing at all. That's a problem with art writing generally. Sentences can become very dense. You end up using specific art terms to try to refer to complex ideas, but if you don't know those terms and their references it becomes gibberish. It's a difficult task because you are trying to talk to so many people. You want it to be interesting to people who know about art, as well as for those who don't. But I don't think it's the space to show off your research as an artist, because it can end up undermining the work, and over-explaining it."

Exhibiting internationally can bring its own problems. "I've sent statements for exhibition catalogues, for example, for a biennial in Italy and a show in China. In both of those, the English text has been translated into Italian and Chinese, and then back to English, probably via google translate. So the Italian one is really flowery, and the Chinese one is unintelligible." Given catalogues 'travel' —they are looked at by curators, dealers and collectors worldwide and often provide depth of information about an artist's work—this is really counterproductive. Even though he had asked for proofs from the Chinese exhibition, "they sent me the catalogue after it was printed and it couldn't be changed".

These situations aside, does David normally get involved in how the labels, wall panels and information sheets are produced? "Generally I do approve texts", he says, "but the reality is that the drafts normally come at a time when I'm thinking about the exhibition and making new work. I don't have the time or attention to give it unless something stands out as offensive, wrong or bad. But it's such a strong frame, I really should give it more attention."

Writing about the arts is in the ascendancy at the moment, both in terms of publication and of process. In some important ways, the UK cultural policy system prioritises the ability to write about your work (or have someone else do it expertly), which is also why catalogues are so important, as part of the evidence, or indicators, of quality. David agrees. "If you're ever going to engage with a UK Arts Council, writing is an integral

part of that, as are statements about your work, and being able to contextualise your work. I think the best strategy it to try to make the writing a piece of work in its own right, because it makes it much more interesting to read."

Writing about their work is hard for many artists though, because on the whole they choose to work in visual mediums and this is where their talents lie. "It's great for your career if you can write. In some ways the arguments you are setting forth are more important than the work. It's not necessarily practices that are being validated, it's more positions." There is a real power imbalance, he thinks, between curators and artists. "Curators have a lot of power, much more than artists. To be exhibited at a major public gallery, a work or an artist has gone through a series of hoops and tests by exhibition. But these days the power of authentication in the art realm is fundamentally with the curator." I wonder if this prestige and influence is why the notion of the curator has such mystique and desirability? Everyone, it seems, wants to be a curator. Nothing is selected any more, or even edited, but "curated". This prestige accounts at least in part, I think, for some of the pretentiousness and lack of humour that can be a feature of curatorial texts. They seem to scream "take me seriously". Often the curators are going through the validation processes themselves. So given that the presentation of art is such a minefield, what advice can David offer to other artists?

"Particularly with larger institutions, there are quite convoluted structures to produce different types of texts. So keeping a handle on all that and getting to see everything before exhibition is often difficult, especially while you're trying to produce work", he says. "My advice

is to try to make sure you're having a good conversation with your main contact, which is often the curator." And lest you think that being an artist is all about glamour and parties (well it is sometimes), here is David's parting analysis: "Being an artist is often a very delicate political game."

David Blandy is an artist who highlights our relationship with the popular culture that surrounds us, investigating what makes us who we are. Blandy has exhibited in galleries and museums internationally, including Kiasma, Helsinki; Künstlerhaus Stuttgart; and Baltic, Gateshead. In 2010 he was winner of The Times/The South Bank Show Breakthrough Award. He is represented by Seventeen Gallery and his films are distributed through LUX.

Child of the Atom, 2010, HD Video, featuring illustration by Inko.

Biters: Son of Song, 2014, HD Video, made in collaboration with Larry Achiampong.

David Blandy **on Video Art**

Ever wondered what the difference is between "video art", "artist filmmaker" and "moving image" works? Me too, so I asked David Blandy.

"It comes from the distinction between artists using traditional 8mm and 16mm film, and the performance artists and others who started using video in the late 1960s. The performance artists started using the Sony Video Rover when it was introduced, which was often referred to as a Portapak, because it was the first portable camera", he says. "So you had a distinction between artists who are directly referencing film—the history and materiality of film—and artists using video, which was more related to television and mass culture. It's immediacy suited performance artists particularly. Another element of 'video' work was using the video edit suite as your medium, mixing lots of found footage. That sort of practice morphed into digital work around the year 2000, when domestic computers became good enough to edit video files."

"Once you're working on a computer, you're no longer working on physical tape. By the time I got to the Slade School of Art in 2001, Final Cut Pro was out, and everyone was using digital tapes. You just loaded it into your computer, which converted it into data. That was what you were manipulating and editing."

"The vast majority of artists these days are using video, as opposed to analogue film. But sometimes they're referred to as 'artist filmmakers' even though they're working with digital video. The words actually mean very little. It's more an indication of where the artist situates themselves conceptually. There's a trend towards saying 'moving image', but when you write a panel for a gallery wall, it sounds a little clumsy to say 'moving image' work. If a gallery wants to show off, they'll say HD [high definition] video, to differentiate it from SD [standard definition] old video. But the quality of SD is shockingly pixelated when exhibited in the now-traditional black box set-up, where the video is projected onto the whole of one wall so it's rarely used now. HD is ubiquitous nowadays."

The Artist Experience:
Richard Wilson

Richard Wilson is a *very* big name in the art world, although you may well be more familiar with some of his artworks than his name. Richard and I talked about his career, his practice, how the presentation of artists' work has changed over time, and, of course, issues of interpretation.

For an artist of his stature, he is remarkably down-to-earth. Making me a cup of tea in a *Hang on a Minute Lads, I've got a Great Idea* mug, he says: "When I first started, there was never any wall texts. It's a current thing. It's about art as education instead of art as experience. Everything has gone plc and it's plc thinking. I came from the art world when it was on the hoof. Those days are gone." Richard has always been quite maverick, coming from what is now called a "DIY" background—making the art works he wants, scrounging materials and spaces. Despite his considerable successes, he has not overtly played the 'art-business' game.

How would he describe the major themes of his work? I ask. "The fundamental theme over the last 20 or 30 years has been playing with site specificity and installation within the discipline of sculpture", he says. "I take man-made forms that people think they know—ships, boats, planes, and particularly buildings and the space of architecture—and turn it all upside down and mash it up. The classic example is if you can take a gallery and fill it with a hazardous waste material, black gooey oil, which people fight wars over, and people come out saying 'that's the most beautiful thing I've ever seen'. You've transformed their pre-conceived thoughts of something." He is referring to *20:50*, the artwork which made his name when it was first shown at Matt's Gallery, London, in 1987. He filled the gallery waist high with oil and installed a sunken pathway to enable visitors to walk into the middle of the room. It is widely regarded as a seminal work of the twentieth century. Critic Andrew Graham-Dixon described it as "one of the masterpieces of the modern age", and *The Telegraph*'s Alastair Sooke thinks it's "a contender for the most important work of British art of recent decades".

Richard has represented Britain in the Sydney, Yokohama, Sao Paulo and Venice biennials, in a context where representing your country, in art as in sport, is pretty much as big as it gets. But true to his character and the less commercial era of the 1970s when he learned his trade, he has, to date, avoided becoming what he calls an "uberartist"—an artist who operates as an international business brand.

"I wasn't interested in having a gallery, because I don't like that model of doing a show and then waiting two years and doing another show. I'm more the American model", he explains. "I was raised on the land artists of the late 1960s and 1970s, and all that experimentation. Work that was semi-permanent. Artists like Walter de

Maria, Gordon Matta Clark and Mark di Souvero weren't doing anything of domestic size. They were producing *Lightning Field*, or cutting a building, or making *Broken Kilometre*. Real things in the real world."

20:50, Richard Wilson, first made for Matt's Gallery, London 1987

"I do think a lot of stuff produced in England is very oriented towards one type, and that is the domestic market within the commercial gallery framework. But that's just one aspect of the art world. I don't do Top of the Pops, I do free improvisation." These musical metaphors remind me that Richard is also a musician, but it's fair to say his work is also very popular. He makes pieces that are immediately accessible to a broad audience, but also have embedded metaphorical content that resonates on deeper levels.

His recent successes include *Turning the Place Over* in 2007, a landmark sculpture for the Liverpool European Capital of Culture 2008 year, in which he cut an 8-metre diameter disc from the facade and windows of a disused building, and attached it to a motor which rotated the section, literally turning it inside out in a cycle lasting two minutes.

In *Hang On a Minute Lads, I've got a Great Idea,* 2012, he suspended a red, white and blue coach over the edge of the roof of the De La Warr Pavilion on the south coast of England, in a re-staging of the iconic scene from the 1969 film *The Italian Job,* starring Michael Caine. For the Aichi Triennial in 2013 he made *Lane 61,* a bowling alley lane, complete with skittles, that hydraulically forced its way out and back again through the walls of its building. His monumental sculpture *Slipstream* for Heathrow airport's new Terminal Two building was unveiled in 2014 and will be seen by an estimated 20 million passengers a year. What does he think of how his work is filtered through to the public? I ask, aware that some of his recent works have been written about in quite simple terms. "When I'm delivering an idea to a client, I *always* give my first draft notion of *why* I want to do what I'm proposing. I always start very formally with an idea and then I come round to context. With the De La Warr Pavilion, the project was on the south coast, where the land meets the sea, and where the sea meets the sky. It's all about edges meeting. It was an iconic building and I thought, it's the edges of the building that interest me and the beautiful cantilevered window balancing out on its own. So I started taking photos and making drawings, and thinking about having something teetering on the edge, like the coach in *The Italian Job.* When it became a Cultural Olympiad project, I suddenly realised that the red, white and blue of the coach was like a flag; I was thinking about end-of-the-pier rides, and there was all this history of Britishness. And in the film, the characters were going to Turin for gold, just like our athletes were going for gold. But it was also about that very precarious moment of winning or losing in sport, and that very precarious moment about an idea working or not working in art."

Does he retain control of how his work is represented in written publicity and interpretation? "I do a draft, and it does get edited and precied, and rather watered down. There have been situations where I have actually queried the edit. The general answer is that, 'we don't always have a highbrow audience, and we don't want to frighten people'. I've always counteracted that with the idea that if people don't get stretched, they always stay at Stage 1. What I've found is that when you *are* being really serious about your work, and you do write *sensibly* about your work, you do get a very good audience. With the Heathrow Terminal Two piece, I was talking about how democratic the piece was and that was absolutely accepted. But there have been situations in the past where that would have been deleted."

Does he always see a final draft before something goes to press? "I always ask for a transcription. In some situations, it gets chopped around and it doesn't make any sense to me, so I chop it back and say it has to be this way. I've done that recently with somebody about *Slipstream*." Do they then do it his way? "They do it my way. I now have that power—I never had it before but now I have. Because I can say 'don't run it, I don't want my name on it'. It's never got that ugly, but I have said, that's not me, that's not my words. On some occasions people put other interpretations in, but that's their take on it, and I've let it go if I think it's okay." We discuss differences between the UK and elsewhere. "I would say in Europe the writing is more flowery and has more depth. They really examine it in the context of their position and where they are coming from. After that, the big jump is Japan. The human rules and the customs are very different there. Their interpretation is coming from a position of your place on the land or the planet, of where you are now in time. They see the symbolism of the work. I rather like that."

Turning the Place Over, Richard Wilson, Liverpool 2007

We discuss how he likes his work to be presented in galleries, and the level of detail that needs thinking about is interesting. "I have had people ask me if they can put up signage or explanations, and I've tended to err on their side because of the nature of the spaces. If you go to *20:50* at the Saatchi Gallery, there's a photograph of

me and under it is an explanation of the thoughts around the work. Normally I would never have that, but I said you can, but the trade off is that I don't want exit signs or fire extinguishers—they can be outside the room. I don't want all that busyness. With most exhibitions, I've said, yes, but could it go behind there, or outside the space, and they've been pretty lenient."

He tried something new with Slipsteam at Terminal Two, tapping into the digital possibilities. "What we did with *Slipstream* was to decide to have no notices in the airport. We made a catalogue that went out. But when you're in the airport, you get a bleep on your iPhone or iPad, and you can download the whole history. You can go off on tangents, watch the films, and have the experience of seeing the piece as well as the virtual experience about the piece. But if you go to the airport, all you've got is the sculpture."

"I believe totally in spectacle, which is kind of a dirty word in the art world. Because you've got to grab an audience, particularly if like me you work in the commissioning sector, where your sculptures are not just in galleries, but on roofs, in holes in the ground, in churches, in theatres, in derelict spaces. They sit on facades, or in buildings or out in the landscape, and you've got to be able to talk to your audience. The majority of that audience are not versed in the grammar of art, they haven't had that privilege. By the use of spectacle, you try to distract them from the mundane, but you've got to be aware that you are competing for their attention."

What is his own view then; does art speak for itself, especially if you use the technique of spectacle, or does he find written labels and wall panels helpful?

Hang on a Minute Lads, I've got a Great Idea, Richard Wilson, De La Warr Pavilion 2012

"Sometimes I do. If there's a necessity to glean some extra information", he answers. "The last time I found it engaging was with the exhibition of Dennis Hopper Photographs in Berlin. I didn't know that Hopper had been a photographer. To read some of the stuff was very

interesting, to discover some of the things he'd done, and where he'd been, with the Civil Rights marches, for example. That's an example of where it really does assist the viewer. But I know there have been some situations where I haven't had enough nourishment back from the reading, where I felt I needed a bit more."

His career has been long enough that he can note differences in how galleries present art. "I think we're all used to today's way of informing a public, which is a dumbing down, of being very matter of fact, of being statistical. There's no interpretation, but I suppose that's quite deliberate, because they're trying to let the viewer interpret. I know people who hate to be told too much, and I'm a bit like that, but there are times when I've come across an artist or an exhibit I want to know more about. Where I've found myself looking at something and got excited by it, I've bought the book to familiarise myself more."

Which is, I suppose, the current thinking in lots of galleries; that we all have access to the internet and the time, energy, focus and headspace to look up information after the event. Or we will buy a book at the gallery's shop, adding to their income. But I do think this is a very middle class view of gallery visitors, and it implies that those visitors reflect those middle class values and lifestyle. It assumes money to spare on books, and it assumes digital knowledge and devices. It assumes individual agency, that a gallery visit supersedes the demands of the 101 other things, and situations, that are going on in someone's life once they've left the art behind. I wonder how many galleries really acknowledge this basis of how they operate? It's another reason why I think providing information where and when it's needed is important.

But back to my interview with Richard Wilson. He has been enormously articulate, honest and engaging. And on balance, he's given me a slightly precarious thumbs up for the role of written information in museums and galleries.

Press Release: Karel Hodd's *Volume with Three Voids* wins public vote for Fourth Plinth exhibition in Trafalgar Square!

Image: Alistair Gentry

For immediate release

Feel good factor continues for rising star Karel Hodd as he wins the popular vote for Fourth Plinth status!

Art world newcomer Karel Hodd continues his meteoric rise by winning the popular vote for the Fourth Plinth. Hodd's *Volume with Three Voids* will be installed on the prestigious Fourth Plinth in London's world famous Trafalgar Square late next year. The Fourth Plinth sits outside the National Gallery and is notoriously empty.

The artist said "I'm gobsmacked, I really am. It just goes to show that the community knows what they like, which is well-made objects that they understand. Art doesn't have to be confusing and up its own backside."

The Mayor of London said "Mr Hodd proved his popularity during the London Olympics when his work was showcased to millions of viewers worldwide as Britain triumphed. This is a fitting acknowledgement of his talent and ability to communicate to a massive audience of ordinary people."

Art works of a temporal and performative nature have been installed on the Plinth since 1999, and selected by committee since 2005. Having identified a shortlist of contemporary artists, the public was invited to vote for their favourite.

Notes for editors:

Following the success of Hodd's landmark intervention in the East London Olympic Park and the triumph of UK athletes, the artist has achieved popular acclaim. His pragmatic down-to-earth artworks are seen to be a refreshing comment on the dominance in contemporary art of difficult conceptually based artworks. Future projects include landmark site specific installations in Paris and New York.

There's Something About **Biennials...**

Biennials are time-limited visual art exhibitions that show a large number of art works by different artists, often in a range of indoor and outdoor sites in a specific location, and sometimes commissioning artists to make new art especially for the event. As the name suggests, they take place every two years (although to complicate things, some are every three, five or ten years). In the UK, Liverpool Biennial is the oldest and biggest biennial, closely followed in age if not size by the Whitstable Biennale, with the Folkestone Triennial taking place every three years since 2008.[2] There are a handful of specialist biennials as well, focusing on photography, ceramics, print etc, which are generally much smaller and don't necessarily commission new work. But across the world, there are about 150 visual art biennial events, more or less different from each other in structures and models, but usually with enough common features that they form an international network and 'biennial family'.

That, at least, is the aspiration. Like many aspects of the art world, there is an hierarchy, with the oldest and most established biennial events making up a Top Ten of world biennials in terms of perceived status and prestige. The mother of all biennials is the Venice Biennale, begun in 1895, and it's closely followed by Sao Paulo, Sydney, Havana, and the Istanbul biennials. With status and recognition comes the making of individual professional reputations, visits by international 'star curators', Russian oligarchs, other billionaire collectors, funders, and,

ideally, a mass of tourists, all spending money in hotels, restaurants, shops and transport systems in the biennial location. It's a complex situation that continually re-affirms belief in the cultural and social values of art, with a cynical deployment of destination marketing techniques.

In the contemporary art world, artists and artworks, money and power are inextricably intertwined. The art and sometimes the artists are flown in to exotic places; rich and privileged people fly around the world going from one biennial to another, with a scattering of art fairs and auctions in between; elite parties take place, large numbers of back-room deals are agreed, artistic and curatorial reputations are confirmed and occasionally, made. The party comes to town every two years, stays for a short period, and leaves. This is a kind of caricature of biennial and art fair culture that can be considered superficial and irrelevant. Like all caricatures, it contains elements of truth and exaggerates them. But there is a fierce drive for new biennials to become part of this elite art club. If art world esteem is gained, then the perception is that a considerable number of other benefits will follow.

I think this is at the root of why some biennial texts are difficult, complex and, to be blunt, sometimes just *bad*. Despite being public facing, the people that the organisers really want to read them are staff of other biennials, influential curators from the world's institutions, gallerists

and dealers, high profile artists, hugely rich collectors, and the most influential international critics. These are the small group of people who decide whether a biennial is noteworthy or not, and their opinions count. Generally, the humble local audience comes last on the list.

I love visiting biennials and submerging myself in the art for a couple of days. But I've managed to collect far too many examples of desperately poor interpretative writing while doing that. Here's a few of them.

Istanbul Biennial 2011

The Istanbul Biennial brings in different international curators to select works for each edition. In 2011, it was curated by Jens Hoffmann and Adriano Pedrosa, who organised it as a kind of homage to the Cuban born artist Félix González-Torres, who had died in 1996 at the age of 39. It was a pretty niche specialist conceit, a pet project even, and the dense public-facing labels and wall panels reflected this.

You can see from this label that González-Torres' work is highly conceptual and symbolic, driven by art theory which requires a specialist education to understand. It's actually fairly well explained here—an explanation of what the viewer is seeing, what the artist intended from it, and the symbolism it is referencing. Whether anyone really cares is another question. But this next one is less successful even though again, it tells the viewer what they are looking at, what the artist intended, explains a relevant point about Modernism and makes a political point about the art historical tradition:

> *"Untitled" (Ross)* (1991), the work that inspires this exhibition, is one of Félix González-Torres' candy pieces. The artist defined the work as consisting of an 'ideal weight' of 80 kilograms of candies individually wrapped in variously coloured cellophane, in an "endless supply." The title refers to Ross Laycock, the artist's partner, who died from AIDS in 1991 five years before González-Torres himself did. The work is a portrait of Ross, its ideal weight being that of an adult man. As the viewer picks up a candy and ingests it, he or she is metaphorically eating a piece of Ross' body, a body that is endlessly consumed yet continually reappearing in an "endless supply"—a body that in the early 1990s Republican years in the United States, was often the target of prejudice and fear because of its HIV status. The metaphorical ingestion of a man's body infinitely multiplied, to commemorate or remember it, recalls the sacrament of the Eucharist, in which bread and wine cease to be what they materially are, and are transformed into the body and blood of Christ. "This is my Body," Jesus said, "This is Ross' body," González-Torres seems to be telling us, as we eat the candy that he generously offers up.

a symbol, not portrait

Too many ideas in too short a space, none of which are satisfyingly explained.

Is the artwork a failure if you need to read an essay to understand it?

> The work by Félix González-Torres that inspires this exhibition was made in 1994 and consists of a sheet of paper bearing a perfect grid, minimally composed and drawn in graphite, intersected by a diagonal line descending from the upper-left corner to the lower-right. The grid is the ultimate modernist emblem; it announces modern art's will to silence, its hostility to literature, to narrative, to discourse One of the principal-strategies of González-Torres, a Cuban Puerto Rican, was to infuse the traditional high-modernist art historical canon with themes excluded from its repertoire: the stuff of everyday life. In this work he does it to a seemingly silent and well-balanced grid. The shift in reading is provided by the title, *"Untitled" (Bloodwork— Steady Decline)*. What this clean and classical grid in fact represents is the declining state of a person's immune system as it is consumed by HIV. The abstract grid is no longer detached from the world but bears a loaded, urgent, and infected narrative. As a personal and bodily representation, it becomes a picture of life and death.

[Handwritten annotations:]

IS DESCRIPTION HELPFUL OR FILLER?

TOO DENSE! MODERNISM NEEDS MORE THAN 2 SENTENCES TO EXPLAIN IT! AND THESE ARE DEBATEABLE INTERPRETATIONS.

→ WHAT SHIFT?

{ REALLY?

The difficulty is that it goes beyond factual explanation. It makes absolute statements (telling not showing) that precludes an individual response from the viewer, effectively telling them what to think, and implying that any other thoughts are less valid. It starts to use a poetic didactic language that is common in academic lectures, asserting a viewpoint that reeks of authority. To understand the work, the viewer has to understand High Modernism, and even then, I'd say some of the notions expressed here are dodgy.

What becomes most important with this artwork? The text, without which the work is largely inaccessible without an art degree; the artist's intention, or the artwork being exhibited?

Apart from the last sentence, which is written in academic language and refers to theoretical concepts, this is intelligible to a particular type of visitor, if not exactly engaging. It seems to me that the real issue with this edition of the Istanbul Biennial was the challenge set by basing it around art that is so densely intellectual and high concept, rather than visual. How do you make this accessible not just to an audience of art world insiders (which is easy) but to a broader range of visitors? Would longer panels help? Possibly, but do visitors want to read essays written in academic English, which may not even be their first—or even second—language? What about visitor tours with informed and skilled guides? It would probably help, but even then it would be difficult to gain more than a limited understanding, and a major undertaking to organise by the Istanbul Biennial.

All three labels (and others within the exhibition) were aimed at those with a high standard of humanities education; by implication, of adult age, fluent in the

The work by Félix González-Torres that inspires this exhibition is *"Untitled"* (1998), one of his dateline pieces, in which groups of names from history or popular culture are written in white type on a black background along with the years; they occurred or appeared. In *"Untitled"* (1988) we read "Patty Hearst 1975 Jaws 1975 Vietnam 1975 Watergate 1973 Bruce Lee 1973 Munich 1972 Waterbeds 1971 Jackie 1968." The dateline works demonstrate how history can be rewritten via a process of selecting and editing names of places, products, or events, and how with this seemingly simple gesture, the writing of history is brought into question. Also interesting is how the interpretation of the names may change from one reader to the next. "Jackie," "Waterbeds," "Munich," and "Patty Hearst" will evoke different memories and meanings for different viewers. This is the consequence of bringing history into the artistic field, where economies of meaning and signification are accepted as more open and plural and may assume creative and idiosyncratic tones.

[handwritten margin note, left]: A FILLER!

[handwritten margin notes, right]:
DO WE NEED THIS DESCRIPTION? COULD THIS SPACE BE USED IN MORE EXCITING WAY.

A WELL ESTABLISHED COMMONPLACE IDEA — DOES IT REALLY QUESTION?

WHAT DOES THIS SENTENCE ADD? IS IT GENUINELY EXPLANATORY? USEFUL? NECESSARY?

nuances of the English language and probably fairly intelligent. This exhibition and the gallery writing about it, seems to be aimed at the privileged, educated, interested in art gallery visitor, who has the leisure time and money to visit. It cannot be called populist by any stretch of the imagination, despite the 200 odd artworks on show by some of the world's best artists.

Does this mean that difficult exhibitions such as this one shouldn't be shown, or if it is, shouldn't try for a wider audience? Of course not. But it does reflect differences in cultural practice and policy between the UK and Turkey. The national Government of Turkey, and the municipal authority of Istanbul, gives very little money towards the arts. In Istanbul, the production and presentation of art is reliant on large amounts of private sector sponsorship which mostly comes from huge trans-national corporations. Their aims in supporting art have very little to do with audience accessibility, or in attracting what

in the UK are called "diverse" audiences. This is very different to British cultural policy and its attached public funding from a range of sources. The arts depend on this money, from national government, and through the distribution of Lottery proceeds. The UK Arts Councils, local authorities, and independent trusts and foundations place considerable emphasis on range and engagement of art visitors, in all artforms. This means that arts organisations, and often artists, are obliged to provide mechanisms that will make it easier and more rewarding for a varied range of visitors to participate in art. From a policy perspective, the ideal annual audience would be representative of a cross-section of British society, in terms of ethnicity, social background, age, gender, wealth, ability, disability, advantage and disadvantage, and would number a high percentage of the population.

So the type of exhibition presented at the Istanbul Biennial in 2011 could take place in the UK— although it

would be very unlikely in the biennial format—but there would be an absolute premium on providing "ways into it". In all likelihood it would be free to visit (there was an entry charge in Istanbul); there would be far better signage (the Istanbul venues relied too much on familiarity with the city), and more and better information. Most importantly, extensive thought would be put into identifying what visitors might need to understand the show, and to providing it through different mechanisms, including different types of general, community and education projects and materials. Money would be spent on trying to make this exhibition enjoyable, as well as understandable, and it would be built into the project from the planning stages onwards.

This edition of the Istanbul Biennial illustrates the point I made earlier, which I've echoed here. Too often biennials, and those involved with them, are more concerned with their own status and professional ambitions. They prioritise talking to each other and a wealthy educated elite of the art world, rather than with a representative cross-section of local and regional residents.

But sometimes, these kinds of labels slip into UK events too. The 2012 City States exhibition in the Liverpool Biennial suffered from some horrible labelling. I've been a huge fan of the Liverpool Biennial since the very first one in 1999. I've written my MPhil thesis on it. It has great ambition, and many strengths, regularly transforming the streets and venues of Liverpool in a massively exciting way. It has embedded projects that work with many people in local communities to change life in the city for the better, and it makes a point of using local suppliers where it can. It always includes fun, quirky, very good art. Unlike the Istanbul Biennial, it is publicly funded

From the geographical and socio-political histories of Wellington, Aotearoa New Zealand, practitioners David Bennewith, William Hsu and Marnie Slater extended connections to the port city of Liverpool through outsourcing and assemblage. Notions of distance, local matter in global circulation and the fluidity of ocean waters inform and encapsulate the work that takes form as printed material.

Today as our primary communication tools are online, publications have the potential to become deliberate sculptural objects, rather than simply a way to distribute information. This turns the making of a book into a building process and the construction of a space In *Watermarking* the book has become a structure that hosts various ideas related to publishing practice.

Reflecting the ongoing necessity of the ocean as a physical and geographical expanse in which industrial entrepreses connect, printers from Wellington Melbourne Taipei Rotterdam and finally Liverpool were invited to visualise this space within the pages of a publication each imagining and inscribing the colour of their harbour's ocean.

HOW DOES THIS MAKE CONNECTIONS?

DON'T WE TALK ANYMORE? WHAT ABOUT TV, RADIO? PRETENTIOUS + DIFFICULT TO UNDERSTAND: WE NEED THE OCEANS FOR THE PHYSICAL DISTRIBUTION OF GOODS?

ALL OVER-WRITTEN + VERY TENUOUS!

from a variety of sources, and audience participation and engagement has been a central principle for the organisation. But somehow these managed to slip through:

The label on page 51 accompanied a shallow water tank with paper drowned in it. The work was conceptual and visually uninteresting. This label attempts, I think, to talk up a weak work to make it seem better than it is. It implies seemingly important notions that sound vaguely intellectual but are meaningless against the work. The effect is that the viewer is confused into thinking the problem is with them, for not "getting it", rather than with the art—that is, if they struggle through to the end of the panel.

> *Black Pillow* is a collaborative project by Lithuanian architects and artists Audrius Bučas and Valdas Ozarinskas. The project has one object—a huge inflatable black pillow. The first version of this work was produced in 2010 for the exhibition Formalism at the Contemporary Art Centre in Vilnius. The two architects' formalist idea was initially supposed to appeal exclusively to the limits of the viewer's phenomenological experiences. However, it quickly got wrapped in various stories and interpretations due to its unusually large dimensions, menacing black colour and the moods that prevailed in Lithuania at the very peak of the economic crisis. *Black Pillow* took a symbolic shape and dimension accumulating all the possible personal and collective failures of our lives.
> This the second version of the work, has been modified in shape and size by Audrius Bučas and Valdas Ozarinskas according to the given space.

[handwritten annotation, left margin:] NOT MINE!

Yes, it was an enormous black pillow, and no, it wasn't possessed by the devil, dark powers, or even the spirit of painter Mark Rothko, whose symbolism this piece of writing is, I suspect, trying to evoke. Perhaps it was exhibited to great emotional response in Vilnius, but how feasible is it to re-present work and expect the same resonance in a completely different atmosphere, location and culture? This work was shown crowded amongst approximately 50 others on a large open-plan industrial floor of a disused Royal Mail sorting office. The use of the word "phenomenological" is gratuitous and "going for a high score in a game of scrabble", as artist Alistair Gentry would say. I still can't make out what an "appeal to the limits of the viewers phenomenological experiences" actually is. Further, the text presents the work pretty much as a dead museum piece, rather than a living breathing art work that can gather new meanings in this different context.

Phenomenological means "the science of phenomena as opposed to the science of being" according to Collins English Dictionary, or in more detail: "The movement founded by Husserl that concentrates on the detailed description of conscious experience, without recourse to explanation, metaphysical assumptions, and traditional philosophical questions." Is this large black inflatable pillow intending to represent our anxieties, fears and

[handwritten annotation:] → WHAT? THIS MAKES NO SENSE AT ALL

[handwritten annotation:] Author showing off - many readers won't know this word. In-house, complicated jargon talk.

THERE'S SOMETHING ABOUT BIENNIALS

pessimism about politics, our personal lives, and the collective life of our nation? Watching the news does that for me, not looking at this artwork.

This theorises a phrase and theme, using educated intelligence rather than knowledge and relevance. A non-art audience may not understand the very loaded meaning of the word "exoticism"—which tends to refer to non-white, non-Western cultures being positioned as different and 'other' from the norm. This leads to the charge of "exoticism" as significant criticism; suggesting ignorance of geo-political power relationships and historic imperialism, as well as a status quo mindset of Western-centric thought; which at the least suggests insensitivity to other cultures, and at worst suggests condescension and lack of equality.

> *The artists in All Are Quests explore the relationship between self and the city within contemporary society. Subjected to interchangeable power structures and ongoing inequality, they deliberately de-emphasise both locality and exoticism. Instead, they observe the changing culture of Hong Kong and reflect on recent developments of the city from the position of art.*
>
> *Notions of the individual and city that are entrenched in the dichotomy of subject and object are untenable. Affinities between people, events and our environments correspond to changing values and structures of global societies. The idea of cultural identity in this exhibition is fluid, whether well adapted or provisional. Can we adopt hospitality—by extending it or by receiving it—as a creative solution to life's paradoxes, as away to embrace the torrents of life?*

And what is "the position of art"? It's a clumsy phrase at best. This is attempting to cram too much meaning into too short a space, plus over-complication. Overall it reads like an excerpt from an academic lecture which because the main body is missing, simply doesn't make sense. The final sentence is an add-on, attempting to shoehorn the work into the overall theme of the survey show, adding nothing to the reader's understanding.

City States 2012 was curated by the Hong Kong Museum of Art, and this style suggests a concern to replicate traditional Western notions of written interpretation. By using an overtly intellectual language, it appears to be seeking acceptance and validation from traditional Western academic and art centres of authority. Possibly these panels were written by someone for whom English is not their first language. But they didn't serve visitors well. How did they slip through the Liverpool Biennial's in-house curatorial vetting I wonder?

COMPLEX ACADEMIC WAY OF SAYING WE ARE INTER-CONNECTED WITH OUR ENVIRONMENT, + SHAPED BY OUR EXPERIENCES, CULTURES + POLITICS.

SOUNDS LIKE EXOTICISM TO ME!

[2] "Biennale" is the Italian word for biennial. The Venice Biennale, now in its 56th edition, was the first biennial in the world, initiated in 1895, and still the most prestigious. Consequently, many events call themselves a "biennale" regardless of which country they take place in or the language spoken.

"It's quite interesting. I like the mixture of paintings and sculpture. I usually go to Tate Modern to be honest but I heard Tate Britain was renovated, and I haven't been here before so I thought I'd pop down. The Phyllida Barlow was quite a wow. I do like art, I studied it at Foundation. I did notice there wasn't as much information about the pieces, but then I'm curious enough to go away and look up something if I want to. So it does force you to find out about an artist rather than being spoonfed. Some pieces had details on the actual artist and background that I thought was quite nice. If you have an interest in art then you might recognise some of the names. When I studied art we had to do art history, which made me curious. If you like art enough you would find out, if its just something you want to see that's where it would end. For me personally, not having the labels is deepening my experience, although I don't know how everyone else has found it. If they had information in the bookshop or a book on an artist that I had found interesting here, I would tend to buy something. I have my iPhone but not my iPad. I haven't looked anything up on it because this is my time away from technology."

Abbie Gordon from London at Tate Britain

Indefensible Words
Luborimov-Easton

Artists Iavor Lubomirov and Bella Easton regularly send press releases about their projects. They are always steeped in the art or project they are presenting, trying to communicate the complexity of what they are doing. Their art training, knowledge and intellect is very much on display through their writing. As such, these press releases are generally not easy reads, and are also unlike other press releases which tend to play more by the rules—an easy hook, headlines, simply written.

I asked them to write a defence of the type of art writing that they and others produce; art writing that can be dense and full of art terminology, where content is more important than style. Here's what they said.

We are Iavor Lubomirov and Bella Easton. We are artists and curators, conference organisers and speakers, press release writers, marketing and PR people. We are gallery directors, customer service managers, event planners, painters and decorators. We are everything and anything that artists learn to be to get their projects off the ground. Our lives are a marriage of idealism with pragmatism, and this harnessing of seemingly opposite qualities towards a singular purpose is at the heart of the language we use to talk about art.

Language is an everyday tool. It needs to serve the most prosaic exchanges and the most refined articulations. It is a curious mix of efficiency and caprice, of intimate and global use, of what can seem like jargon or private language and yet often be understood across distant cultures and geographies. It is our everyday job to navigate and balance the sub-language of art, which is also an international intra-language. We strive to understand our mix of audiences and adjust our language accordingly, by using or avoiding terminology and by writing in a less or more expansive or explanatory manner. But who are our audiences and what are we trying to communicate and why? And is our use of art language necessary or justified?

One of the most pertinent examples of the way we use language in the context of art is the regular writing of press releases for exhibitions at our project space LUBOMIROV-EASTON. These one-page essays conflate a multiplicity of the purposes required from writing about art and from using art language. The most obvious purpose of the press release may be to communicate to a gallery visitor something necessary to their viewing of the art. This usually unquestioned assumption and practice can cause the press release to present itself as a kind of lorgnette,[3] through which comes closer focus on the intimate magic unfolding on a stage, at some intellectual distance from the audience's naturally limited vision. This of course isn't true, nor is any one gallery visitor like another. So a press release is in constant danger of becoming the most superfluous thing. A throwaway piece of paper, crammed with impenetrable jargon, serving as a fog to hide what flaws the unsteered eye may find in

the work, or a prop to enhance the standing of an object, which cannot justify itself unaided. Most gallery press releases are picked up, folded and discarded unread. The audience does not have time for such condescending nonsense. The rare gems of writing one comes across, which do serve the purpose of illuminating an exhibition, are easily missed.

But a press release is not there just to serve the viewer. It also has to be faithful to the needs of the artworks and artists, the curators and art writers. It becomes part of the documentation process, which aims to preserve something meaningful from the exhibition (in that every exhibition is an installation and has a temporal, and in a sense performative element to it, which is lost once it is taken down). Along with photographs, the press release is a contemporary source. The press release also serves the gallery and curator, both as an expression of their vision, and as an addition to their portfolio, and even as a prop to their status, real or perceived. When an external writer is hired, then the writing also becomes part of that writer's portfolio.

Because we organise a variety of projects, our press releases display this variety of purposes quite clearly. The language and the terminology changes significantly. One of our ongoing interests is the accelerating growth of the artist-led project. Something happens when artists start curating, showing and working together. Priorities are different. That's what we believe anyway. This is the reason we do projects like T*he Opinion Makers, SUBLET, or the Conference for Emerging Art Organisers*: to focus in on the halo of activity around art, and of the population that surrounds it—the curators, gallerists, writers, critics, interns, socialites, collectors, media, academia.

Here are two press release extracts. The first is by writer Emma Brooker, talking about the way that an artist-in-residence at our project space creates large self-portraits, which are in fact landscapes of body:

"Autolandscape offers us the experience of travelling without moving; we encounter the body as a landscape of great familiarity and strangeness, a place we inhabit but can never fully know—which is the start and end point of every human journey."

This next one is written by us for the first Opinion Makers—a show of paired juxtapositions of one work by an artist-curator, together with one work by an artist of their choice.

"The Opinion Makers is a pragmatic attempt to use the artist-curator as an explicit tool for understanding curation. It is also a statement about the significantly expanded presence of the artist-led approach in the contemporary curatorial landscape."

Both press releases address a different kind of audience and express different concerns. The first talks to a gallery audience directly about art, while the second addresses curators. Although the second press release is also concerned with art, it approaches it more generally and through a specific perspective—its relationship with curating. While in the art exhibition press release, language can be difficult in proportion to the complex ideas present in the art, there is something softer in the writing, and though the words are not specific art world terminology, they describe metaphysical ideas about the body in a tone that is used frequently within art. With The Opinion Makers release, the language

becomes sharper and terminology about curating and organisation is used. We start to make assumptions about the audience's familiarity with certain concepts—emerging, artist-led, contemporary, curatorial landscape. We feel our way around these different ways of using language, as we try to navigate a middle course between the practical necessities of communication and a need to express something deeper. At times we feel that there is something in the art or the ideas around it which justifies the use of complex language.

Because we are first and foremost artists, our direct concern with art is never too far removed in what we write or why we write. Our most recent travelling project, Collateral Drawing, examines both art in itself and the framework of making around it. We investigated the role of the studio as an extension of the canvas, or the art-object. And so the language we use in the press release is a mixture of addressing a gallery audience and communicating with our peer group of curators:

"Every artist has their own unique working method that habitually causes repetitive marks to be inflicted onto their studio surfaces. Whether dripped, scratched, taped, cut, erased, smeared, hammered: all are repetitive and typically unguarded instances of the process of drawing."

The words in this text are accessible—they don't seem like jargon. The language of art often makes use of existing words, such as "modern" or "contemporary" and invests them with new meaning. However, to every artist this paragraph is full of terminology, of words heavy with art history and part of an established vocabulary of art. Simple words such as "process", "drip", "scratch", "mark", "surface" are recognisable from a long-established and ongoing conversation about the making of art, what art is and the role of the artist. At the same time, when used in the right way, they can let the reader into the text, without asking them to know about the history of these words. The language of art needs no defence. It is both beautiful and necessary as a language, as any language, in all its forms. We believe that the first duties of art language are to the art and the artist, but we also believe in the value of striving to make language inclusive, so long as this doesn't interfere with the truth of the text.

Iavor Lubomirov and Bella Easton run ALISN: the Artist-Led Initiatives Support Network. They organise collaborative events such as the Goldsmiths Conference for Emerging Art Organisers and off-site projects such as *The Opinion Makers* and *Collateral Drawing*. They programme residencies and solo or curated exhibitions at the LUBOMIROV-EASTON Project Space.

[3] Opera glasses. Used to magnify the action on stage in large halls where seats may be quite distant and the detail unclear.

A happy Harrison family at the Hayward Gallery, London, having toured the Martin Creed exhibition.

Charlie Harrison, aged 11

I think it's really cool because there are loads of things you don't expect, like a room filled with balloons, and a big spinning neon sign saying "Mothers" and a scrunched paper in a glass box. I thought the signage was fine.

Betsy Harrison, aged 8

When we came out of the balloons it was really funny because your hair was all sticking up. The car was really scary because you didn't know when it would activate. We didn't need anything explaining to us except where the toilets were.

Paul Harrison (dad)

It's the first exhibition that I've taken the children to that has made them laugh and that's what I think has been of huge value. So they see all this stuff in a different perspective. I thought the texts were very clear. The explanations were very good and humorous. I love his cheek. I'm assuming that he would have written them, as they have his tone. We always read the texts when we come to a gallery, and we find them generally very helpful.

The Hayward produced a booklet called *What's the point of it?* which contained an A-Z of Martin Creed. Written by the Interpretation Manager working closely with the artist, it had idiosyncratic understandable paragraphs that seem to have really worked for the Harrison family. Here are some are some random excerpts, without the accompanying images, to give a flavour of what they liked:

Ambiguity

Much of Creed's work arises from uncertainty. He doesn't want to make judgements or to choose between one thing and another. As a result, he thinks that 'what something might mean to someone is unknown'. He sees 'yes and no' as being preferable to 'yes or no' and says that it is possible to 'choose everything', if you want.

Conceptual art

Martin Creed is often described as a conceptual artist. This is not necessarily correct. He says: 'I don't believe in conceptual art. I don't know what it is. I can't separate ideas from feelings ... Work comes from feelings and goes towards or ends up as feelings. It is a feeling sandwich, with ideas in the middle.'

Expressionism

If asked to categorise his art, Creed would call it Expressionism: 'everything that everyone does is always an expression. Whether you're answering a phone in a call centre or making a piece of sculpture which is going to be exhibited in an art gallery, it's creative. People express themselves in everything they do.'

© Hayward Gallery

The Art of Conversation
Alistair Gentry

For another view, from an artist who is also a talented writer, here is Alistair Gentry on what he thinks art writing should do. Exhibition writing is not just about creating source material and documentation, he argues, it should be because the art is only as important as the people who will see it.

I'm rude, sometimes. I talk too much. Very often I know—or think I know—what the other person is going to say, so I pre-emptively start in on my response. I try hard not to, but the more invested I am in the conversation, the more likely I am to do it. I can also instantly monologue and rant on almost any subject, or virtually none. To all the people I've interrupted over the years, to all the people whose sentences I've finished because apparently you were taking too long, to all the people I've talked over and disrespected, I apologise sincerely. The only mitigating factor is that the more I've done it to you, the more interesting you probably are. But having said all this, even I know very well that a conversation is not about waiting for the other person to stop so you can launch into what you planned to say from the beginning. A conversation is not just for you to say what you want to, and get what you want. If both parties are to walk away from a conversation feeling equally satisfied and valued, there needs to be a dialogue; not two competing, overlapping monologues, or a soliloquy to a silent audience.

Unfortunately, art writing is often a blaring megaphone monologue that leaves us nowhere to get a word in. We're lectured at. Like simpletons we're told what we think, what we see, what it means and what it does not mean, what we *know*. Sometimes we're so baffled by what's being said that we can't tell what the subject or purpose is, so there's no way we could respond cogently. The analogy from everyday life would be if everybody you spoke to obviously and visibly found you boring. Sooner or later, a wise individual would get around to considering the possibility that it isn't only other people's fault. They're not necessarily philistines or imbeciles. You are in fact being boring. As artists or art writers, do we really just want to say our piece with no comeback from the people to whom we're supposedly speaking? Isn't art for other people, not just for ourselves?

Writing about art can be wonderfully enlightening to its readers. At the same time, my view is that an art work is an utter failure if it absolutely *needs* more than a few helpful sentences to support it. If a work of art can be described and grasped fully without experiencing it, then to me there is no point in the art work. I know there's a whole critically-approved school of art exactly like this; art whose origin lies in precious conceits instead of ideas or aesthetics. It's art for the age of the Like button. There's certainly nothing to be gained by writing several thousand words of impenetrable ramblings about it, except the aggrandisement of the artist or—more commonly—the writer, critic or curator.

One of the dirty little secrets of the private gallery and artist-led sectors (and more than a few public galleries, too) is that almost nobody from the general public ever sees anything they put on. It can be because of the space itself, or because the staff are terribly intimidating unless you're happy to brazenly walk into random buildings without knowing who or what to expect, which most people aren't. Sometimes they don't particularly want or need the public cluttering up the place, because the art has hardly any purpose except sale to a particular clientele. It can be because the gallery is unfortunately situated, deliberately hidden away, or just in a town, village, or part of the world that is unlikely ever to be a major destination. The gallery may rarely be open. It can be because, frankly, nobody else cares about the artist or their art.

Irrespective of the reasons, if it weren't for private views and various other booze ups for cronies, their footfall would be close to zero. If an artist shows their work at a gallery and there's no public to see it, did the artist really show their work? Therefore many galleries, being all too aware of their potential irrelevance, resolve this paradox by writing elaborate apologias and critical frameworks for their otherwise invisible exhibitions. Who could possibly see all the gallery exhibitions, or even all the exhibitions in major cities like London, Berlin, New York or Tokyo? Indeed, the global elite of artists and curators counts upon this barrage of things to see. Without the art being available for comparison, it's hard to refute their claims for it. The curator and the artist don't need to succeed or fail by the merits of their work if virtually nobody sees it. They can float through the inflated fantasy world created by their art texts instead.

These texts sometimes make more sense if you've seen the exhibition. Often they make *less* sense if you've seen it. All too frequently they make no sense at all, either way. The incomprehensible in pursuit of the unjustifiable, to paraphrase Oscar Wilde. The tree fell and there was nobody around to hear it, but here's a long obituary for the poor unloved pile of lumber.

If an artist is an amateur then I think it's fine for themselves and their loved ones to be the main audience for their work. For everybody else, your art and your art writing have absolutely no meaning unless you face outwards and begin a conversation. Art texts that only make sense to artists should be on the curriculum at art school, if they must appear anywhere, in the same way that there's no need to publish 40 pages of equations in a newspaper article about physics. Specialised language is undoubtedly useful and necessary in some contexts. It's no crime to send your reader to the dictionary, now and then. Unfortunately, some writers of art texts misuse, misunderstand and abuse words so alarmingly that sometimes they come across as barely literate. Present artists and art writers are particularly prone to sloppy, misbegotten appropriations of the technical language used with great precision by scientists. Many artists and curators increasingly and spuriously act as if they're a type of scientist, too.

Some types of jargon have a more sinister purpose, though, especially in art. This type of writing about art is one of innumerable small blocks in the Great Wall of Jargon (visible with the naked eye from space) that deliberately seeks to exclude outsiders, and in the process to reify the writer's own monetary, class and educational privileges. This stifling upper middle classness has for

several centuries alienated and rebuffed certain types of people from the full time practice or enjoyment of what is called, with increasing irrelevance, Fine Art. Those excluded are the usual types: working class people, the poor, the self-taught, the talented but unconnected, the uncommodifiable, the subversive, the transgressive, the rural, the provincial, the suburban, the un-Westernised, those individuals who can't or won't grit their teeth and talk the talk. In short: most of us. International Art English jargon empowers a tiny clique of artists, curators and academics by systematically disempowering the majority.

I'll tell you another thing that's just plain rude. Pretending to extend an invitation to people, then talking complacently amongst yourselves while they shiver outside your door.

Alistair Gentry is a writer and artist. He has been artist in residence at New Media Scotland, the University of Edinburgh, English Heritage, and ArtSway, among others. His book 'Career Suicide' is about the lives of non-famous artists (ie most of them). He has also written two novels, a short story collection, critical texts and journalism.

Stills from *Stendhal Syndrome* (Performance lecture, 2011). Video version of a lecture about the medical syndrome afflicting people who have seen too much representational art.

THE ART OF CONVERSATION

Magickal Realism (Performance lecture with live video mix, 2009–2013). Left, handbill for the performance. Right, performance photo.

Art Space: Thinking-Making Interpretation
Amanda Philips **and Dr Abigail Moore**

Since 2000, Amanda Phillips and Dr Abigail Harrison Moore have collaborated on a core module of the MA in Art Gallery and Museum Studies called "Interpreting Cultures". Undertaken by students in their first semester, it introduces them to key issues of interpretation. The module encourages them to question practices and theories, through case studies and texts, to investigate the role of interpretation. In this essay, Amanda and Abigail talk about how they work together to achieve this.

The School of Fine Art, History of Art and Cultural Studies at the University of Leeds has benefited from a long partnership with the City's museum and gallery service. As part of this, Leeds Art Gallery enables students to experience one approach to interpreting contemporary and historic art displayed in a gallery for diverse audiences. Students are introduced to questions of collection and temporary exhibition interpretation at the beginning of the module, through critically reading several texts and, over the first five weeks, the development of a public exhibition at the University Gallery. In the interim weeks, examination of interesting examples of interpretation practise fosters questions such as:

- Whom do we interpret for?
- How do we recognise and acknowledge subjectivity in interpretation practices?
- How do we challenge the hierarchies of curator, interpreter, visitor, and participant?
- How do interpretation practises reflect wider institutional, social and political contexts?
- How do we transform such analysis into practice?

Our ambition is to explore narratives—of interpretation, and art objects and their makers, of art institutions and their local physical and ideological location, of 'learning' in galleries, and of the gallery education role as a 'case study' in its own right.

Leeds Art Gallery, Image David Lindsay

Leeds Art Gallery has created a specific room within its building to facilitate the exploration of such debates. Art Space is a re-purposed room architecturally structured by a large central staircase, a floor to ceiling window and doorways to two galleries. It is both open and awkward. Introduced into the Gallery in 2008 as part of refurbishments, it features specially commissioned multifunctional furniture for use by adults and young people and a "sculpture-impressive notebook", in effect a display stand for comments left by gallery visitors. Organised as an open-access area, it is a place for intergenerational creative fun and learning inspired by the Gallery's collection and temporary exhibitions.

Art Space is managed by the Gallery's Education Office and staff. Volunteers and young people on work experience generate 'things to do' inspired by artists and artworks, most frequently those displayed in temporary exhibitions. It is an informal space, with some of the Gallery rules relaxed—eating and drinking are permitted, for example. Responding to the rhythms of the Gallery and its exhibition programme, Art Space activities change a number of times during the year. It also hosts artists to facilitate activities as often as possible. Feedback has shown that Art Space users especially enjoy access to artists, believing them to add new ideas, skills or support specific to their expertise. But it is its continued use and the number of positive comments left that demonstrate its overall popularity and success.

Both the MA module and the work that we do through Art Space aims to reveal and question historical concepts of interpretation. We focus particularly on the tradition of written interpretation in art galleries, from label to catalogue, as the main way of offering knowledge within galleries or museums. The arguments about access to galleries, both mentally and physically, have been going on for many years. In England they took on a new dynamism with the development of postgraduate training in art gallery and museum studies 40 years ago, and through the research of those most closely involved in setting up these programmes such as Emeritus Professors Eileen Hooper Greenhill and Susan Pearce at the University of Leicester. There has been a move away from entry as a privilege, to entry as a *right*. We have travelled from a time when, at the first English exhibition of Contemporary Art in 1760, visitors were described as "great numbers whose stations and education made them no judge of statuary or paintings". We are now celebrating free access to UK museums and galleries and focussed on enabling engagement for all in our national and regional art collections.[4] As Hooper Greenhill famously declared, "museums and galleries have shifted from being static storehouses for artefacts into active learning environments for people".[5]

This shift from objects, to communication about objects, remains dominated by the written word. Despite much discussion dedicated to the dialectic of the aesthetic versus contextualised display; to the amount of words needed and the value of words at all, many exhibitions still use writing as their key form of interpretation. There is, of course, much value in this. As visitors we often seek out the label or panel to identify the artist and title, the medium and date alongside some sort of meaning. We have also come to expect signage and leaflets, and have become familiar with the reading area, digital interactivity and gallery trail. At the same time, however, many curators and educators have challenged the dominance of writing and reading in exhibitions, citing the need to

engage visitors from a very diverse range of educational and social backgrounds and, as importantly, to encourage the *active* participation of these audiences.

There have been many experiments to encourage a more active participation in the written word, such as framing texts as questions rather than answers, but galleries have also been exploring alternative strategies for interpretation. They are seeing the written word as only one part of the interpretation mix.[6] Hooper Greenhill signalled this turn in the final chapters of her 1994 book, *Museums and their Visitors*, when she not only challenged museums and galleries to respond to the needs of all visitors, (for example, families, school groups and people with special needs and disabilities) but also questioned the types of language used to tackle the 'problem' of authoritarian and non-inclusive uses of written words in the museum environment. Since then curators and educators have responded in many ways to her call to pay attention to the language that we use, and to make museum texts "accessible, easy to read, and meaningful both within the context of the exhibition and in relation to the personal context of the visitor".[7]

In the last two years Art Space has been used to deliver aspects of the University of Leeds Museums Studies module "Interpreting Cultures". The module delivery partnership has a history, but the position of Art Space within it is new. Given that we teach through the debates that we have, both with the students and between ourselves, we thought it appropriate to structure the rest of this essay as a debate, to draw in our own and wider analysis of interpretation practices to help set up some of the questions about interpretation, why and how it matters.

Within the six years it has been active, Art Space has continuously attracted users of all ages and interests. It has seen adults make artworks, do crosswords or simply sit. It has been used by teenagers as a place to hang out, as a setting for meetings, a suitable space for breastfeeding, and as an appropriate environment for a supervised visit by social workers, or social experience by care workers and their clients. Art Space is purposely designed to be 'interactive' and immersive, recognising diverse learning needs and styles. It enables the students to engage in an interpretation strategy that does not rely on words. Instead we use art practise and creativity to support access to challenging and complex artworks or ideas. It also offers the opportunity to ask questions, and students are encouraged to analyse and debate. They may choose to take some of these questions and solutions back to their own exhibition planning, but we emphasise that our approach is just one approach, framed by institutional necessity as well as a wish to open up new possibilities to new audiences.

It also presents a challenge for the art historian as gallery education worker—as Amanda is—bringing together postmodern theory about meaning construction, the job of challenging barriers to participation in art and galleries, and supporting individualised, meaningful learning though and about artworks. It values lifelong learning, employs education theory and methodologies, and navigates the diverse demands for 'Education' in a gallery. Throughout the Masters programme we are keenly aware of the need to combine theory and practice. Some students choose to complete their formal placement with Amanda at the Gallery and so gain further experience for their CVs. We consistently remind students that success in any career in museums

and galleries starts with the ability to ask critical questions to help drive their ideas forward, and the analysis of Art Space as one of many 'live' experiences of practice on the programme is part of this.

Exploration of Art Space as an aspect of gallery service delivery draws attention to the complexity of interpretation of art objects. As each layer of its 'politics' is brought to the fore, students engage with different museological questions and practises. A taken for granted assumption that art is important is unsettled by the recognition that not everyone thinks so, and variety in cultures and communities will result in differences that need to be taken into consideration when interpreting art in galleries. They come to see that galleries as professional working environments are fora for debate and struggle over meaning making, financial and ideological viability, a testing ground for new ways of doing and thinking within the profession—and perhaps more boldly, within society in general.

Seeing Art Space as a case study challenges the idea that bridging the gap between viewer and object is done simply by the passive transfer of 'knowledge'. It demands thinking about the combination of factors that contribute to 'knowing' in a gallery—the space, the context, the institutional histories and politics, the nature of the audiences that already attend and those we would like to engage, etc. We aim to entice our students to become deeply engaged in their studies and potential future career, and want them to be active and thinking practitioners with audiences in mind. The questions Art Space raises are rooted in the art object and processes of its making and display, as well as what art institutions contribute to society.

Art Space utilises words as anchors for the activities, materials and furniture it brings together as part of exhibition interpretation. In their most intensely simple form the written interpretation of artwork or art process acts as a provocation within Art Space and leads to thinking and making. Except in reality it doesn't. Providing some sort of ground and confidence, the words are ignored and Art Space participants take materials and ideas in a direction of their own choosing. I used to think that this was some kind of problem that needed resolving, but now I see it as proof that the interpretation strategy is doing its job well.

Amanda Phillips is Learning and Access Officer at Leeds Art Gallery, UK.

Abigail Harrison Moore is Head of School, School of Fine Art, History of Art and Cultural Studies, University of Leeds, UK

⁴ See Kenneth Hudson, *A Social History of Museums*, Michigan: Humanities Press, 1975, p 15. See also Eileen Hooper Greenhill, *Museums and the Shaping of Knowledge*, London: Routledge, 1993, and *Museums and their Visitors*, London: Routledge, 1994, and Susan Pearce, *Interpreting Objects and Collections*, London: Routledge, 1994.

⁵ Greenhill, *Museums and their Visitors*, p 1.

⁶ See Sharon MacDonald and Paul Basu, eds, *Exhibition Experiments*, Oxford and New Malden: Blackwell, 2007, for a much wider discussion of both the history and practice of experiments with exhibition making and interpretation. See in particular Mieke Bal's chapter on "Exhibition as Film", where she explores an exhibition that, as the editors say in their introduction to the book, 'seeks to expose what [Bal] calls "the work of exhibition"—the narrative strategies and frames through which exhibitions position viewers and offer up particular, positioned, readings, p 5.

⁷ Greenhill, *Museums and their Visitors*, p 139.

Art Space, Leeds Art Gallery, Image David Lindsay

Are you Questioning Pre-Conceived Ideas?

Please don't. It's a hackneyed and problematic phrase, horribly overused in artists' statement, gallery texts and press releases. It creaks and grates. It's as presumptuous of the visitor's unknowable ideas, and as authoritarian in its intention, as the status quo the artist is supposedly trying to challenge.

So what's wrong with it? Well, first, it assumes that all members of the audience not only have pre-conceived ideas, but that these ideas are at best misguided, if not entirely wrong-headed. That's a bit insulting to your audience. Second, the wrong-headed pre-conceived ideas being challenged are rarely articulated, and therefore neither are the questions the artwork is 'asking'. So it's vague, uninformative and sometimes confusing as well.

It gives the unfortunate impression of superiority over the viewer, which is more likely to turn them off than on. And in work that is politically or socially based, this presents an irony that is usually missed.

All in, it's a double whammy of patronising artspeak.

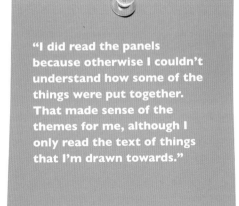

"I did read the panels because otherwise I couldn't understand how some of the things were put together. That made sense of the themes for me, although I only read the text of things that I'm drawn towards."

Ailsa Haxell from Auckland, New Zealand
at Manchester Art Gallery

Curatorial Balance

There has been "a crisis of authority in museums" for a long time, and a genuine recognition that historically, galleries and museums have reflected the dominant culture of which they are a part. As a result, traditionally they have perpetuated ideas regarding power structures in society—patriarchy, colonial perspectives, Britain as Great Britain the Empire (and the equivalent in other countries). For the last 35 years or so, museums and galleries have made strenuous efforts to better reflect society as it is—postcolonial, structurally unequal, multicultural, class-based, amongst other things.

Curators are very much aware of this difficult background, especially if they have formal training (see the Art Space essay in this volume). But to make it even more complicated, gallery staff in publicly funded organisations will also be aware of UK cultural policy. This emphasises the need to increase visitor numbers generally, and to cater for what is called "non-traditional audiences" (usually defined as children and families, young adults, and BME audiences, which stands for "black and minority ethnic").

More broadly, galleries and art events have become part of the tourist offer, in what is known as "destination marketing"—where a city or region is marketed nationally and internationally to high-spending tourists, with the cultural 'offer' seen as an important part of the mix. High profile international sporting events like the Olympics and the Commonwealth Games epitomise this, as do awards such as European Capital of Culture. But beyond tourism and the economic benefits this brings, the ultimate aims are usually to position a city or region as an attractive place—to live, to work, and to do business.

There is also another aspect of "high art" that makes it very attractive to 'peripheral' countries, and that is its historical associations with Western Enlightenment values and the notion of being a "civilised society". For those countries wanting to be taken seriously on the world stage, participating in the international arts infrastructure is highly desirable. Culture has become part of what politicians have taken to calling "diplomatic soft power".

All these ideas have driven the worldwide expansion of art biennials, art fairs, and the establishment of new art galleries. They bring varied and significant pressures to the arts infrastructure. Gallery professionals and curators will be aware of these different agendas, especially if part of their funding comes with specific targets relating to them.

A curatorial role differs from organisation to institution, and nationally and internationally, but in the contemporary art world, curators basically spend their time doing two things: looking after collections, and "making exhibitions", as curator Lewis Biggs describes it, with characteristic

modesty. A curatorial role requires wide-ranging professional knowledge and intellectual ability. Curators know that what an institution or organisation chooses to exhibit, as individual artefacts and as collections of items, and how it writes about them, is central to how it disseminates information, values and perspectives. This has led to a heightened awareness and endless discussion about what labels and wall panels should say, and a plurality of different opinions and professional responsibilities.

I spoke to three highly regarded international curators to discuss their perspectives, and how they translate their understanding of the theory into practice. Omar Kholeif is Curator at the Whitechapel Gallery in East London; Lewis Biggs OBE is a former director of Tate Liverpool, director of the Liverpool Biennial from 2001–2011, and now a freelance curator working in the UK and Asia; Gerardo Mosquera is a freelance curator based in Havana, Cuba. He founded the Havana Biennial in 1984 and travels the world working on different projects.

All three express some ambivalence about written interpretation. Their view is that it a necessary tool, but it's not 100 per cent desirable. "My preference is to create exhibitions that need no written interpretation" says Lewis "because I am less interested in developing audiences than in commissioning great artworks. I believe that if you show people great artworks, the artworks do their own audience development." Lewis specialises in large works in the public realm, which is usually a different type of art to that found indoors in galleries. For gallery art, Gerardo Mosquera thinks that labels or appropriate interpretation, is necessary: "Even for the most sophisticated audience, works have specific references that you need to communicate through wall text or labels. Art has become very specialised and you have to know so many references to understand it thoroughly. So for curators and artists, it is a challenge, and you need to think about non-artistic means that an exhibition can use to achieve communication. We are all grateful if you can give some clues that won't go against the art." Omar Kholeif's experience is shaped by his work within institutions. "It's part of every curator's job to write interpretation and it needs to be engaging, accessible, and presenting the kernel of an original idea, which is what makes it different from marketing material. I write interpretation every week and it's always a struggle whatever the project. You are the closest to the work and its thematic development, which could involve years of research. Then other departments step in, such as marketing, who want to speak to an audience that sometimes seems invisible. They will try to encourage you to think about who you are writing for, and make changes, which is where the meaning of a text can be altered. Sometimes this back and forth between departments means that the finished text becomes neither a meaningful piece of interpretation or even useful marketing."

This echoes a point that Dr Curtis made in her interview, about the processes of interpretation becoming hardened over time in bigger organisations. Omar explains: "In larger institutions, there can be institutional branding guidelines in terms of word limit, limits on adjectives, writing in the first person or the third person. I want to use the first person because the reason I've chosen a work is because it has moved me in some way. Exhibitions need to come from an individual, not a faceless brand." Again, he is echoing the perspective of Dr Curtis, who also likes the idea of "authored" exhibitions.

One of the strategies Omar uses is teamwork. "I find it quite useful to invite people from other teams into my projects. So we'll do an away day or morning with the communications, education, development teams, and talk about how we might want to articulate the exhibition. I also always work with the artist on the text (if it's a monograph), and will ask them if they want to use it as a site for research or as an artwork, but being very clear that whatever we produce has to provide access to the work." As a professional writer, he comes from a similar perspective to myself, and that of Alistair Gentry: "I'm interested in having as many people as possible read what I write because I deal in universal ideas. I tend to have a conversational tone, even for catalogues. I want to take the reader with me on a journey into the artist's mind. You need to be confident in what you are saying and doing, and be able to argue your position. Impersonal interpretation is a kind of safety shield for the people and institution. But I prefer subjectivity which is becoming more common."

Lewis Biggs asks himself the question: "Who needs this written interpretation and what interests them? Then I write it for them, and present it typographically appropriately to that audience (big for people with partial sight, audio for people who like that, waterproofed for outdoors, on clipboards or filing cards for people who like that, in child's writing for young people, in video for film and TV addicts, etc)." He makes it sound easier than it is, I think. "The over-riding issue is for whoever is responsible for interpretation to know who is the audience they want to reach; or the multiple audiences and how to reach each of these separately without annoying the other audiences who expect something different", he says. "For the Folkestone Triennial 2014

we are preparing large amounts of information on each artwork, including videos with the artist, printed labels, guides printed and spoken, maps, biographical information, and interpretative information. This will all be available via QR code, TAG or BEACON technology. We are doing this not because I don't have confidence in the artworks to communicate on their own (they are all good artworks as defined by being right for their place and audience) but because people enjoy having access to all that information." I think he may be right about this, certainly in a biennial or triennial situation, where people spend several hours on a visit and process it differently—it adds to the overall experience for these kinds of large projects.

I ask if there is a difference between the demands of publicly funded exhibitions and private sector sponsorship? "Again, it's just about the audience's expectations and needs, different in every case", responds Lewis. "It's not a fixed situation" says Gerardo. "In my experience in both situations I have received some constraints. Sometimes there are political constraints. For instance, if you organise a show in China, they won't admit something that goes against official regulations. It's a Damocles Sword hanging above your head, but in the end, there is no censorship. That can happen in Europe too, in both public and private sector, that they don't want anything too radical, too politically engaged, too sexual. But in general, in my experience I have been quite free to work the way I wanted."

Lewis has worked significantly in Shanghai. "The job of the curator is to introduce the viewer to the art and the art to the viewer. The life that the viewer leads (their inherent context of knowledge and experience)

is by far the largest factor in the determination of what an artwork might or might not mean, communicate or signify to that person. People in China lead a quite different life, in many ways, to people in Liverpool." How does that translate into what he does in practise? "The presentation of art starts with what people see, including any written matter. In different cultures—or if they have had different kinds of education—people see, and notice, different things, as well as the fact that they will bring different contextual thinking to whatever it is. When Michael Craig-Martin was a juror for the John Moores Painting Prize China, he remarked how little colour he could find in the submissions. The Chinese artists on the jury were surprised, they had not had the same experience. In Chinese ink painting, black and white contain all colours. In Shanghai, the space around an art object is not 'read' in relation to the object. In temples and museums, for instance, this often leads to what I might regard as incongruity—objects of different conceptual categories placed in close spatial juxtaposition (the fire extinguisher, the guardian's lunch, and the Ming vase); also an indifference to the quality of the surface on which an art object is placed. In crude practical terms, this means that in China I would need to spend time persuading people to clean floors and paint walls; and place the label or text about an object closer to it than I would in the UK, where I would tend to give it more of 'its own space'."

Omar Kholeif raises more political considerations. "You see two types of interpretation internationally. It either replicates Western models with straightforward didactic texts; or the independent type exhibition, in which you find very little interpretation material at all. In Dubai, the art world is very much tied to the commercial sector, so it's minimal. In Sharjah during the Biennial, it's very conventional because it's trying to replicate the traditional Western form."

"In an unstable country, telling the audience what the work is about could get the artist into serious trouble. It's better to let the work speak for itself. Producing an exhibition in a warehouse in downtown Cairo, where you don't want to be seen by any government official, is very different from showing at Tate Modern. Somewhere like Cairo, and numerous places around the world, having independent art activity can be a very risky proposition." He also mentions artists who are playing with the notion of interpretation, incorporating it in their work—for example, US conceptual artist Christopher Williams, "who makes interpretation part of the show"; Constance Stellert who sends a manifesto instead of a conventional press release, and Jeremy Bailey, a Canadian artist who "created different kinds of interpretation using augmented reality technology."

Gerardo is aware of similar political contexts but argues that art is a positive influence in restrictive regimes: "I remember being at the conference at the Sharjah Biennial, and a gentleman from the place said "we need to have this Biennial because this event makes it possible that you— the international intellectuals—are here". The Biennial introduces the possibility of new ideas; to have a Biennial, they have to open themselves up. In the Havana Biennial, the government wanted to be a third world cultural leader, but the Biennial also fulfilled a need to desegregate the art world, which at the time was white Eurocentric." Just because art crosses international boundaries doesn't necessarily mean that it's accessible to all or even understood by the few. Is the art world truly globalised and

genuinely homogenised across the world? (Globalisation tends towards homogenisation, which is why High Streets all have the same shops). Lewis points out that many of the training structures operate internationally, which is likely to attract specific types of people and provide a particular type of education: "50 per cent of the students of English fee-paying schools come from other parts of the globe, I'm told. In time, this does create a homogenised social network of people who have rich parents and possibly share a cultural position. This is not exactly the same as the situation with 'the art world', but the auction houses turn over sufficient numbers of interns to provide a 'universalising' attitude shared by a great number of people. The same is true of alumni of art schools, and of curatorial courses—these are large numbers of people trained to think in similar ways, although not identical in their outlooks. So, there are any number of genuinely globalised homogeneous social sets, yes, and some of them exert powerful influence through control of money or media, but fortunately the diversity of attitude in the production of art usually seeps out the edges." Omar sees globalisation of the art world as a good thing: "The art world is absolutely globalised in that there isn't a centre. Since the millennium there's been liveliness, a greater responsiveness, more interaction with colleagues around the world. There has been a growth of publications, and the media has embraced institutions. What used to be marginal narratives are being seen in mainstream museums, seen by millions. Globalism encourages a much more nuanced conversation about the breadth of practice that exists; a greater examination of the local through a global lens."

Although all three curators have their own set of underlying principles, what is clear from them is that it is impossible—and undesirable—to draw up a set of rules to follow. "The only rule is to be sensitive to the particulars of the situation and to remember that the experience of the art is made by the viewer not by the artist, or the curator", says Lewis. This is echoed by Gerardo: "You have to respond case by case. It depends on the type of show, the audience, the context, the mission, the levels of education of a given culture. It's a constellation of different factors."

The final words go to Gerardo: "As a curator I'm very clear about art being a message. This is one of the challenges for a curator, to find a middle-ground where you achieve communication with a broad audience."

Lewis Biggs OBE

Lewis is a freelance curator, writer and cultural consultant. He was previously Director of Liverpool Biennial (2001–2011) and Director of Tate Liverpool. He is curator of the Folkestone Triennial 2014; co-curator of the Aichi Triennale 2013; General Editor of Tate Modern Artists; International Advisor, School of Fine Arts, Shanghai University; and Chair, Organising Committee, International Award for Excellence in Public Art, Shanghai.

Omar Kholeif

Omar Kholeif is a writer and Curator at the Whitechapel Gallery, London; Senior Visiting Curator at Cornerhouse and HOME, Manchester; and Senior Editor of Ibraaz publishing. He previously headed up Art and Media at SPACE London and was Curator at FACT, Liverpool. In 2012, he was a co-curator of the Liverpool Biennial. His latest books include, *You Are Here: Art After the Internet*,

Sophia Al-Maria: Virgin with a Memory, and *Jeddah Childhood circa 1994*, all published in 2014 by Cornerhouse Books.

Gerardo Mosquera

Gerardo is a freelance curator, art critic and art historian. He was one of the organisers of the first Havana Biennial in 1984 and was adjunct curator at the New Museum of Contemporary Art, New York, from 1995–2009. He is an advisor in the Rijksakademie van Beeldende Kusten in Amsterdam. His publications include several books on art and art theory and more than 600 articles, reviews and essays for magazines.

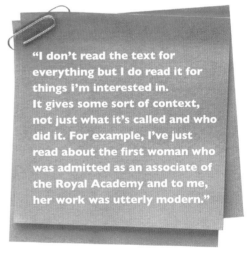

"I don't read the text for everything but I do read it for things I'm interested in. It gives some sort of context, not just what it's called and who did it. For example, I've just read about the first woman who was admitted as an associate of the Royal Academy and to me, her work was utterly modern."

Frances Bell from Macclesfield
at Manchester Art Gallery

Why are Openings Still Called Private Views?

Another day, another clutch of "Private View" invitations arrive, and I wonder yet again why this obsolete term is still being used in the second decade of the twenty-first century?

However contemporary the artist or questioning the work on show, the opening party of an exhibition is still frequently billed as a Private View. It's a desperately old-fashioned term riddled with connotations of elitism, privilege, wealth, exclusion and clubbability.

The origins go back 100 years and more. Patronage was part of the lifestyle of the rich and a necessity for the artist. The wealthy would be invited to a Private View before the exhibition opened to the public. The objectives were to allow them to see the work without the company of the unwashed lower classes, making it a comfortable social occasion for them, but also to promote the exclusive opportunity to buy the most desirable works before they went to the open market. They were a part of the social scene of the London aristocracy, a milieu of dinner parties, opera first nights, dances and hunting weekends, a scene where combinations of the same people gathered time and time again for the latest thing.

Both these notions still thrive today in the commercial art market—substitute "rich, famous or influential" for "aristocratic"—but in my opinion, have limited place within our publicly funded contemporary art world.

And the term seems particularly inappropriate for use by those artists who consider themselves to be questioning "pre-conceived ideas", working at the leading edge of art, or concerned with accessibility.

So why do artists, curators and institutions continue to use this phrase?

I suspect it's because the tradition has not been examined frequently enough, and then thought through in relation to individual practice and career. But I also suspect there remains a psychological need for distinction, and an emotional need to associate with and belong to the "elite of successful artists". Consequently it remains one of the few blind spots for artists, curators and PR companies, as well as some institutions.

So, here's a challenge: if you do still use the term Private View, can you justify it critically and intellectually? Or are there better alternatives?

A version of this text first appeared on axisweb.

Image: David O'Connor

HANDS-OFF OUR ARC!

British artist Karel Hodd is at the centre of a controversy raging across France. His latest art work *Volume with Three Voids: Art de Triomphe* places his trademark brick-like design across the top of the Arc de Triomphe in Paris. But grassroots community groups are threatening to riot if it is not removed immediately. *Art de Triomphe* was commissioned as a landmark sculpture intended to commemorate France's Bastille Day on 14th July, the countrywide celebration of the end of feudal rule in France, and the beginning of the French Republic.

Image: Alistair Gentry

RIOTS AS KAREL HODD'S VOLUME WITH THREE VOIDS: ART DE TRIOMPHE CREATES CONTROVERSY AND ANGER IN PARIS.

French community groups are furious at what they see as a desecration of their culture by the British. Community activist Pierre Beret said: "This cochon has desecrated our Monument. The Arc de Triomphe is a memorial to French fallen soldiers in many wars, and celebrates our triumph over our enemies. That one of our historical enemies should be allowed to tamper with our beloved memorial and debase the memory of our fighting heroes is offensive.

I call on the people of Paris to make their feelings known by demonstrating at the Arc and reclaiming it for themselves."

Paris-based artist Claude Bagette said: "It is a terrible artwork by a dreadful so-called artist. I question the process that led to this commission. It wasn't transparent and the decision-making took place behind closed doors. It is inappropriate. There are many far better French artists who would have made a sensitive statement for this site. This was a political decision made without regard to the quality of art-object, made by a committee of people who know nothing about art."

The Office of the Mayor of France commented: "This is a decision made by a Government intent on squandering the integrity and distinctiveness of French culture on the altar of international diplomacy. I am calling for the immediate removal of this work and an enquiry into how such a debasement of our national monument could have been allowed to happen."

The artist himself wasn't available for comment, but his gallery, London-based Victor Spiro, said last night: "Karel has made a spectacular artwork for a spectacular national event. Personally, I think it has both substance and majesty.

It represents a new level for him and he is very proud of what he has achieved. It is provoking comment, which demonstrates the agency that art has, and the vital role it plays in our societies."

A spokesperson for the British Prime Minister said last night "this is jingoistic nonsense by the French. Karel Hodd is one of our most popular artists and we are proud that he was chosen for such an important commission".

Around What They Teach in **Art School**

Art jargon is often learned in art school, on fine art, art history and curating courses at various levels. It's an integral part of an art education, which, like most professions at a high enough level, has its own concepts and language, often expressed in linguistic short-cuts that those with a similar education would understand. Unlike medicine or engineering though—science based disciplines rather than humanities subjects—art education is complicated by the inbuilt notion of questioning and problematising. It is not enough to learn information and develop and apply knowledge. If a student wants a promising art or curatorial practice, previous practices must be analysed, questioned and challenged.

There are a range of tools available to students (and professionals) to help them do this, but perhaps the most common is known as Theory, or Aesthetics. Theory is the name given to the work of many philosophers and intellectuals, often European, who championed what were at the time new and different ways of understanding art and literature. Freud's work has given rise to psychological 'readings'; Marx inspires Marxist readings and analysis; Roland Barthes popularised the notion of "the death of the author" in favour of the birth of the reader (who bring their own meanings and experiences thus superseding authorial intent). Many Americans theorised Feminism and its meanings and applications, which eventually led to the French school of radical feminism. And in art, Gombrich, Greenberg,

Clarke, Berger and many others added to theories of aesthetics.

But the French topped them all in terms of critical mass and complexity, particularly with the work of post-structuralist theorists like Derrida and Bourdieu, which over the last 30 years or so have become very popular on university art courses. These are all difficult theoretical writers whose seminal works were written at the height of their intellectual powers. Their work is even harder to understand because it was written in French, and rather uneasily translated into English. The result is an awkward, over-complicated and dense art language. Art jargon is often based on these translated versions of intellectual French works; some may think to a counter-productive extent.

Their very difficulty makes the ability to quote or talk in similar ways a marker of elite education for many students and graduates. It's infiltration into the international art world leads many ambitious artists, writers and curators to believe its use is compulsory if they want to be taken seriously. It has become self-perpetuating. Daniel Blight, writing in *The Guardian* in 2013, nailed it when he said: "This is a dialect of the privileged; the elite university educated. If you can't write it effectively, you're not part of the art world. If you're already inside but don't understand it, you're not allowed to admit it." An article written by artist David

Levene and academic Alix Rule published in 2013 analyses art jargon in great detail, calling the resulting language "International Art English". It's "a unique language" that has "everything to do with English, but is emphatically not English" they say.

The idea that education should enable individuals to contribute to the sum of human knowledge, or at least, intelligently comment on it, has been a fundamental principle of Western education systems since the Enlightenment. It's an admirable and even utopian educational basis. But in the arts, the pressure it puts on practitioners and curators, and the prestige that is endowed when you get it right, can lead it to some horrible linguistic misjudgements.

A few years ago when I was researching post-graduate courses, I came across a webpage advertising an MFA Art Writing at Goldsmiths University, led by the academic art writer Maria Fusco. It was an impenetrable wall of jargon that quite clearly said "Keep Out". The not so hidden sub-text was "if you can't understand the writing on this page, don't even bother to apply". It was breathtaking in its arrogance and its utter failure to do the simple thing required, that is, to communicate some basic information about the course (for which substantial fees would of course be payable). I wanted to include a screen shot of the webpage for this book, but it has been taken down and Fusco has moved to another university.

But I came across this example of the type of theoretical jargon that is being taught to students. Published by *Frieze* in 2011, and written by the teaching team on this very same MFA in Art Writing. Here is "11 Statements around Art Writing", with my comments underneath.

"11 Statements Around Art Writing" was first published on the Frieze website October 2011. See frieze.com for further information.

The title first. This isn't writing about art, or even writing about art writing, it is writing "around" art writing. What on earth does that mean? Substituting the otherwise innocent word "around" for the more prosaic but accurate word "about" has become common practice amongst arts professionals at every level. It's intended to signify, I think, the organic nature of art as a topic, which is so subject to amorphous meanings that it really can't be pinned down by anything so precise as talking *about* it. One can only talk *around* it, darling. There's a kind of unspoken political correctness about this. If you say "around", you are implying that you understand a subject is huge, with all sorts of related issues that can be understood on so many different *levels*; whereas if you use the word "about", you are somehow guilty of mono-thinking and single issue crudity. (Bourdieu theorised this as "habitus"—the habitual language that is intended to demonstrate belonging to a desired group).

1. "Art writing emerges as a practice."
Fair enough. But art writing has been a practice for a long time, even in the visual arts, so no necessity for it to emerge (remember Yoko Ono in the 1960s? What about concrete poetry?)

2. "Art Writing is a possible form of the liberty of the image."
I can decipher this to mean writing is a potential but different form of image making. But again, don't we already know this? Artists have been using text for a long time (Dylan, Ian Hamilton-Finlay, Kitaj, Ono, Jenny Holzer, Barbara Kruger, Robert Indiana of LOVE fame, Fiona Banner, to name a few).

3. "Art Writing names an approach within contemporary culture that, in wanting new potentials, embraces writing as a problematisation of the object of art, its dissemination and forms of exhibition."
We're back to the questioning of forms and previous practice that I mentioned in the opening paragraph. It also references our cultural zeitgeist which is constantly looking for the new Next Big Thing. This is fairly standard academic writing, decipherable with thought and effort. You could delete "in wanting new potentials" and add a second and third sentence to explain the nuances, which would make it far less like intellectual razor wire and more like actual communication.

4. "Art Writing does not take modalities of writing as given, rather it tends to, and experiments with, non-division between practice and theory, criticism and creativity."
This one has too many sub-clauses, and is trying to push too many ideas into one sentence. I think it is suggesting that writing can exist in the same sphere as fine art practice, theory and criticism, and experimented with in this context. There's an implication that it should be taken as seriously as theory, criticism and actually making art.

5. "Art Writing sustains all forms of art criticism, including the experimental and the hybrid. The art work may be intensely engaged with, or it may be the starting point for fictional and poetic developments."
The first sentence is redundant: writing is an integral part of art criticism—who knew? Without it, the second sentence is easier—art may inspire critical or creative writing. Fair enough.

6. "Art Writing is in the situation of a fulcrum."
Nonsense writing. This smacks of late night drunken wittering and should never have seen the light of day.

7. "Art Writing is an anthology of examples."
Yes, that's one way of thinking about a body of writing. I like this one, and it makes me want to define art writing and how it is used. Using many more sentences obviously.

8. "Art Writing is re-invented in each instance of Art Writing, determining its own criteria."
An example of self-justifying wish fulfilment? In attempting to legitimise art writing as a serious practice, it is suggesting that there is no place for external judgements. According to this statement, everything you write exists in a vacuum, measurable only with rules of your own choosing. Like saying: "It's great because I wrote it, and I don't care what anyone else thinks"?

9. "Art Writing addresses material literary forms, which draw attention to the spatiality of writing and

the physicality of its support, but the interests of Art Writing diverge from those of literature."

The core of this statement is that art writing has different aims from novel writing. Again, an over-complicated and over-dense statement of the obvious.

10. "Art Writing involves relations between people, as discursive. In so far as it is art, Art Writing can engage public space no longer sustained by ground, including that of truth."

This statement can be analysed (and questioned and disagreed with), but again, it's too dense and has that "public space no longer sustained by ground" phrase. "Public space" is used metaphorically, and "ground" has an academic background that also enables its metaphoric use. In this instance, if you substitute the word "foundations" it makes a bit more sense. But really, this could be rewritten as a paragraph in plain English explaining the authors' desire that art writing be used in a variety of ways to provoke, inspire and create dialogue. (Perhaps rather like I'm trying to do with this book?)

11. "Art Writing institutes such public space without truth, and sometimes disappears into it."

I actually quite like this one, even though it is deliberately complicated and provocative. You need to have some understanding of what "public space" might mean. You might take issue with its suggestion of self-important agency. You want to think about what "without truth" might mean. It's also a self-justifying piece of sophistry that is effectively saying "embrace my contradictions, as I do". But there is a wilful playfulness about this statement that I like. It could be applied as a description, or an aim, to novels, I think.

Pallant House Gallery
Simon Martin

"Interpretation should never tell us what to see, think, or feel." Simon Martin, Artistic Director at Pallant House Gallery in Chichester, shares his perspective on gallery texts, and explains how they are produced at Pallant House.

Interpretation in museums and galleries can often be a matter of taste: some visitors prefer to have an unmediated experience between themselves and the artworks, and others expect and appreciate information in a variety of formats. Much has been written on the perceived opposition of 'experience' versus 'interpretation', but if handled sensitively the two should be united like a happy marriage. Nothing can replace the immediacy of standing before an artwork and *looking* (or using the other senses, if appropriate). Interpretation should never tell us what to see, think, or feel, but instead provide the background or contextual facts that enable the viewer to come to their own conclusion about what they are seeing or experiencing.

At Pallant House Gallery we take the approach of providing layers of written interpretation: maps, wall-texts, short labels and long-labels. These are complemented by a variety of relatively low-technology interpretation including themed tours for adults and school groups, children's activity trails and worksheets, artwork in focus talks, workshops and lectures on artists, and themes in the collections and exhibitions—and occasionally special audio-tours.

Visitors are given a map to help them navigate the architectural mix of Pallant House. We are an eighteenth-century Queen Anne townhouse with domestically-scaled rooms, with a larger contemporary extension that opened in 2006. The approach to interpretation is the same throughout so that the visitor's experience feels as seamless as the transition between the two buildings.

Garden, Pallant House Gallery

The permanent collection displays of twentieth-century British and international modern art are organised broadly chronologically, exploring different themes in each room, but with contemporary interventions into

architectural features such as the carved staircase and fireplaces so that it offers more than a 'heritage house experience'. Within each room display there is an introductory wall panel of about 200 words in a large font, which explains the theme of the display, and its historic or artistic context. Even if the visitor does not read any other interpretation, in theory this text should help them understand the connecting theme or idea behind the artworks on display in that room.

We have a rich mix of historic, modern and contemporary elements at Pallant House. There are all kinds of narratives that could be explored, but the starting point is to try to answer the questions of Who? Where? What? Why? How? The first text the visitor encounters outside Room One gives an overview of the 'collection of collections' and how it was formed: the generosity of private collectors that have donated their works. The next explains the history of the eighteenth-century house and the extraordinary story of the man who built it; subsequent wall texts relate to the theme of the different room displays. All the artworks in our permanent collection are accompanied by short labels that clearly set out standard basic information: the artist's name and life dates, the title and creation date of the artwork, the medium and the credit line for the donor or acquisition method. The labels are presented relatively close to the artwork to avoid confusion about which label relates to which artwork, so both can be seen at the same time. Our labels and wall-texts are designed by our in-house graphic designer, and use a font called *Foundry Sterling*, a modern san serif, chosen for its clarity and readability. The letterforms were designed with special attention to proportion and purity of form. We feel it is elegant with a 'quintessentially English feel' which seems appropriate for a Modern British art gallery.

During our re-development project in 2003–2006 we created an Access Advisory Group. This group includes participants that are wheelchair users and have visual impairments, and provides feedback on everything from the design of the disabled toilets to the font sizes of labels and the height at which they are displayed—to enable both wheelchair users and the average height visitor to comfortably read the labelling. The labels are printed on low-reflective laminate foam card, and fixed either directly to the walls, or onto special Plexiglas holders. In temporary exhibitions in the new wing galleries we tend to use decal lettering and vinyl wall-texts applied directly onto the walls.

Gallery view, Pallant House Gallery

Items such as pieces of historic furniture do not have individual labels on the basis that to label every chair would be intrusive to the experience of a 'domestic' space and unnecessary, when information can be

obtained from the voluntary room stewards around the gallery who are equipped with files with detailed information on such items. However, a considerable proportion of artworks also have additional labels with longer texts of up to about 80 words to provide more contextual information about the artwork. Our aim with the long labels is that anyone from the age of 12 upwards should be able to read and understand the language used in the label.

With displays of modern and contemporary art it is particularly important to provide a 'way in' to avoid visitors feeling alienated by artworks that they do not immediately understand, which can be made worse by impenetrable texts using 'jargon'. The texts are usually written by myself or our Assistant Curator, Katy Norris, but we have also worked with others to provide different voices in the gallery displays. In 2009 we launched the Step Up project to enable five non-traditional artists to work with a researcher and gallery staff to develop four workshop packs, a trail of labels, and to deliver workshops during the award-winning Outside In exhibition, featuring work by artists on the margins. In 2010 and 2011 this continued with 15 non-traditional artists receiving training in leading workshops and developing an audio-trail.

We believe that good interpretation is a key part of helping visitors to engage with modern and contemporary art, to help them understand the often complex ideas behind it, and hopefully inspire them to learn more. Generally at Pallant House Gallery we receive very positive feedback about our interpretation and labelling, so I hope that it is achieving these outcomes!

Pallant House Gallery

Commercial Galleries are **Different**

I've largely concentrated on the publicly funded arena, since these organisations are most concerned with bringing in diverse audiences and ensuring it's a good experience for them all. But how does it work in commercial galleries, the ones that have to sell art in order to survive?

I spoke to Honey Luard, Head of Press and Publications at White Cube, and her colleague Eleanor MacNair. White Cube is the contemporary art gallery founded by Jay Jopling in 1993. It has two venues in London, one in Hong Kong and one in Sao Paulo. Originally famous for representing several of the YBAs (young British artists) like Damian Hirst, Tracey Emin, and the Chapman Brothers, it is now a substantial art business operating internationally.

The enormous Bermondsey building in London is the centre of the White Cube press and publications operation—"our small room upstairs is the world wide hub", says Honey. We have established on the phone prior to the interview that White Cube does not put any labels in its exhibitions—the white cube is literally sacrosanct—but we start by discussing, why not?[8]

"A museum is obligated because their main responsibility is to their audience. There are a whole host of different concerns that they have to take on board before they can even work on the display. But a commercial gallery's primary motivation for displaying the work is not for the general public. Because it's a commercial space. A commercial gallery stands or falls dependent on its ability to sell work by its represented artists. Therefore you are appealing to the collector, whether that takes the form of an individual, a foundation or a museum." But it is more nuanced than this, as Honey explains: "The artist is creating the work because they can do no other. That is their means of communication, and they want that work to be seen. A space like this verges on the public space in that it is absolutely open to the public. That is because the artist engagement is also with their audience—a general audience, a curatorial specific audience, a critical audience."

Although the building is made of plain red brick and not architecturally embellished, it can't really be said to be welcoming. The doors are three times human height and the glass is milky grey, hiding the inside. There is security on the gate, and the spaces inside are cavernous. White Cube's Bermondsey building at least is not on a human scale, and it is intended to impress. Having said that, while I was there, there were some local visitors, including a community group of disabled people.

White Cube does create written interpretation but does it differently from public galleries. "Curatorial text goes on our website and there are discreet handouts

at the reception", says Eleanor. "The public sector tends to have the emphasis on audience—how you attract them in, how to make this artist who may seem obscure accessible, how to pick out something that the audience would understand, and make it interesting. You've got to get everybody. In a private gallery it's very much about *positioning*. It's about writing that text on an artist which may be used again and again as a starting point. It's not about sexing it up. It's about showing where they are in the landscape, about where they could go, but not making outrageous claims."

This all sounds very different from the popular idea of marketing within private sector galleries, where hype is not unknown. Can it be as disinterested as Eleanor makes it sound? But White Cube is a well established gallery operating at a top international level with internationally known highly bankable artists. Some of the world's most prestigious institutions buy works through this gallery, as do some of the world's richest people. This is about selling rarefied blue chip investments in cultural production, and about making art history where possible. Honey, who has been with White Cube since its inception, provides me with an insight into this world when she summarises the history of White Cube: "We have represented living artists who have grown with the gallery. So if you are artist-led in that way, and creating new spaces to challenge your artists, the art community is your greatest critic in a way. That is your first conversation."

She goes on to make a point that is slightly taboo in the public sector. "When John Wilson from Front Row [BBC radio 4 programme on the arts] was interviewing Jake Chapman for the Serpentine, he asked: 'Are children coming in to see the show?', referring to the Ku Klux Klan figures and the film piece that the Chapmans put in there. I'm still rolling his response around in my head because I thought it was fascinating. Jake said, 'But when I make art, I don't make art with the idea that children need to be able to come and see it.' It's got to not offend children, not offend old people, not offend blind people etc, that would be the absolute death of creativity. So in a way, it's also being mindful that being too selfconscious about your audience can sometimes also strangle ideas. So truth be told, *we are a haven for doing anything."*

Do they create different pieces of writing for different countries and markets? "No", says Honey, "we don't rewrite text according to the market, because the texts are driven according to the nature of the work and where we're pitching ourselves at the outset. We do have to have external PR though." The three of us have an involved discussion about press releases and catalogues. Artists love catalogues because they are a traditional form that bestows status, and because they document artwork, an exhibition, a sometimes pivotal moment in their careers. Says Honey:

"The catalogue in its purest form is attempting to give the show an afterlife, to present it in a different media and to open up the conversation. The revenue to fund those catalogues comes from the sale of the artworks, so the catalogue is entirely at the service of the artwork, not of the audience. Because it is funded by the artwork, it is very often gifted to a collector, and also marketed to curators, as a way of introducing an artist or bodies of work to a wider art community."

I remember curator Omar Kholeif saying that, as a rule of thumb, catalogues are bought by one percent of an exhibition's visitors. You have to have a good reason to publish one when it can be such an expensive outlay for relatively few sales.

It's no longer the case that the public and private sectors are separate spheres, never meeting. In the arts there is considerable cross-over and cross pollination. The subsidised arts have long been encouraged to take on ideas from the business sector. And the commercial sector would like the gravitas and prestige that they see bestowed on public institutions. The market imperative must impose its own pressures and constraints, just as public policy does in the subsidised sector. The biggest difference, for commercial galleries is that of choice: the option of whether to include writing about the work they are showing, or not. Most prefer to have a 'clean' exhibition area, where the art is prioritised and positioned in large uncluttered areas, with plenty of space around it and as little as possible to distract the viewer from the object. They might decide to have some information about the artist or exhibition available at the front desk, and sometimes a catalogue is produced, but on the whole, these are discreet and intended not to interfere with the viewer's experience. But balanced against this, although passers by—the general public—can visit commercial galleries, these are not the primary audience that the galleries are catering to, and once in the gallery, they are on their own.

[8] Contemporary art is now routinely shown in bare rooms with white walls—the white cube, for which Jay Jopling named his gallery. This is a relatively new convention, developed in the twentieth century as a modernist concept. Previously, art was shown in more flamboyant and opulent settings, which mimicked the drawing rooms and halls of the aristocracy.

"I know nothing really about art and I think it's interesting to find out more."

Jill Owen from Liverpool at Manchester Art Gallery

NEW ARTWORK BY CONTROVERSIAL ARTIST KAREL HODD TO TRANSFORM NEW YORK'S STATUE OF LIBERTY.

In another controversial proposal, artist Karel Hodd plans to intervene in the semiology of the Statue of Liberty, America's most potent symbol of liberty and welcome to immigrants. It is beloved by the US people, and permission is unlikely to be obtained. In what many think is nothing more than a publicity stunt, Hodd proposes to replace the tabula ansata and torch that the statue holds, with what looks very much like a giant brick and trowel. In a submission to the Port Authority in New York, Hodd writes:

"No one wants the world's poor, oppressed or hungry anymore. What civilised nations want are people who can create and innovate, and so contribute to wealth creation in a society that values knowledge, arts and culture. It is time to update the Statue of Liberty to reflect these new realities."

Image: Alistair Gentry

Hodd's previous work has been characterised by some as biting comment on the art world, and by others as the shameless self-promotion of a charlatan. Opinion is divided over whether this is a potential work of genius or a tasteless leap into the abyss.

Art Bisected Quarterly, Volume 18, 2nd edition

Arts writer Dany Louise commented: "In recent years there has been a massive rise in spectacular landmark art projects, intended by civic authorities to function as a rebranding of their location or their politics. Art has sometimes been appropriated by these authorities to put a prestigious gloss on economic and political booster projects. These can function as a distracting shiny mask for a range of policies and developments that are rarely progressive and at their worst can be actively regressive. These policies often advantage the already privileged, rather than meet the needs of all sections of society."

"Artists need to be aware of the politics behind the new opportunities they are being offered, and make intentional decisions about whether they want to be involved. At their best, artists are public intellectuals, examining society and the human experience of it through the prism of their art, critiquing where necessary. Do they want to find themselves implicated in the worst excesses of the free market for the sake of fame and fortune? Of course it is a very seductive notion, but it is one that should be entered into knowingly; or not at all. Otherwise artists run the risk of becoming apologists for a set of policies and developments that are proven to dramatically increase inequality and injustice in the world."

About **Interpretation Matters!**

This publication presents various arguments about how and why galleries write about art for public information. Many galleries do it very well indeed, and it's clear that there are a range of different methods and motivations for producing information, as well as new emerging formats. You might think that the simplest way is good clear information in the gallery at the point of looking, or you might prefer minimal information at this point and to research before or afterwards. Currently, traditional methodologies still predominate but how will it look in the future? I suspect that new technologies will play a bigger role as generations of 'digital natives' grow up, and new technologies are invented that maybe we can't yet imagine. But reading and writing are the simplest tools, and affordable to everyone. This format is going to be around for quite a while yet. Our encounters with writing are still very powerful. An aim of this book was to highlight the practice of writing in galleries, and to provoke conversation and response about the subject.

This book is part of a wider project called Interpretation Matters! The project works with art galleries to stimulate positive experiments in different ways of writing interpretation using four strands of activity, of which this book is one.

Website: www.interpretationmatters.com

Readers of this book are warmly invited to contribute to the Interpretation Matters! website. If you visit galleries, this site enables you to offer feedback about your experience and participate in the conversation. You can comment on any page, write a blog post, and submit a Good Writing Citation or even a Tortured Language Alert (published anonymously!)

If you are an artist or gallery professional, there are many resources available on the site, including case studies and research. This is also a neutral platform for discussion within the sector, and for virtual conversation with gallery visitors.

Workshop Programme for Galleries and Art Centres
A programme of bespoke workshops for gallery staff and audiences. They enable organisations to review their process of writing for the public, identify an 'organisational voice', and what language and principles best expresses that voice. Follow up workshops explore how audiences experience and respond to the gallery's written texts, identifying language they are most comfortable with.

If this sounds like something your organisation would benefit from, email me at:
talk@interpretationmatters.com

Are you Talking to Me?
A three-screen art-text exhibition provides institutions with another mechanism for gathering audience feedback.

Contact details:
www.interpretationmatters.com
talk@interpretationmatters.com
Twitter: @interpmatters

About Dany Louise

Dany is a UK-based writer and critic focusing on the visual arts and cultural policy, contributing regularly to *The Guardian*, *New Statesman*, and *a-n Art News*, amongst others. A freelancer, she also works closely with arts organisations on projects and research that has a strategic impact for them. With 20 years experience as an arts professional, she has worked in organisations large and small, including Arts Council England. She initiated the Interpretation Matters project in 2013. Her MPhil thesis examines the interface between biennials of art and public policy within a neo-liberal context.

Acknowledgements

Grateful thanks to all the contributors who have been so generous with their time and expertise:

Lewis Biggs
David Blandy
Dr Penelope Curtis
Luborimov-Easton
Alistair Gentry (who also cooked up the character of Karel Hodd with me, and created the four images of the fictional Hodd's work)
Jessica Hoare
Omar Kholeif
Honey Luard
Eleanor MacNair
Bridget McKenzie
Simon Martin
Dr Abigail Harrison Moore
Gerardo Mosquera
Hannah Nibblett
Amanda Phillips
Emily Speed
Natalie Walton
Richard Wilson

For collecting vox pops: Hannah Nibblett,
Chris Brown of g39

For reading drafts: Geoff Molyneux, Jane Zachazewski

Supported by: Arts Council England, without whom Interpretation Matters would not exist.

Black Dog Publishing Limited
10A Acton Street, London WC1X 9NG
United Kingdom

t. +44 (0)207 713 5097
f. +44 (0)207 713 8682
info@blackdogonline.com
www.blackdogonline.com

Designed at Black Dog Publishing.
British Library Cataloguing-in-Publication Data.
A CIP record for this book is available from the British Library.

ISBN 978 1 90866 88 9

Black Dog Publishing is an environmentally responsible company.
The Interpretation Matters Handbook is printed on sustainably sourced paper.